NATIONAL GEOGRAPHIC
PHOTOGRAPHY
FIELD GUIDE
DIGITAL
BLACK & WHITE
with film techniques included

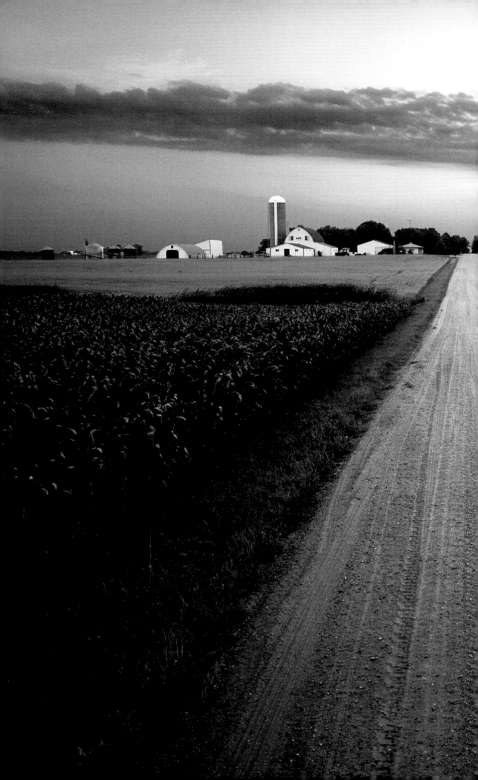

NATIONAL GEOGRAPHIC
PHOTOGRAPHY
FIELD GUIDE
DIGITAL
BLACK & WHITE
with film techniques included

Text and Photographs by RICHARD OLSENIUS

NATIONAL GEOGRAPHIC
WASHINGTON, D.C.

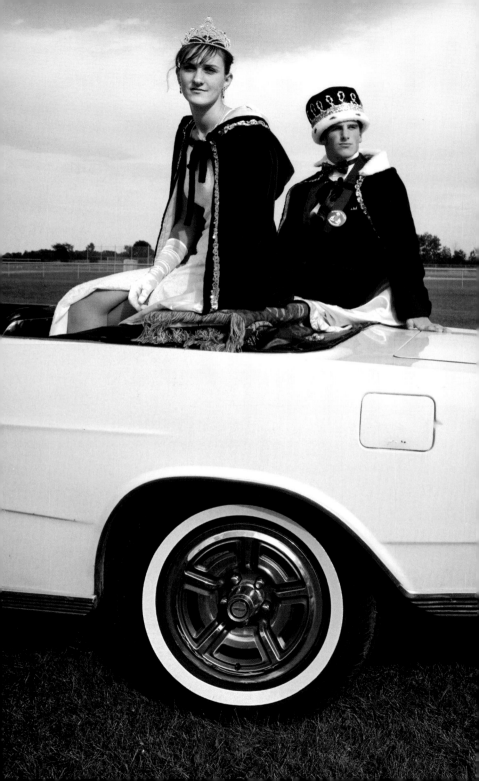

CONTENTS

PAGES 2-3: Strong compositional lines combine with soft late-afternoon light in this classic use of black-and-white large-format photography.

OPPOSITE PAGE: Making this portrait of a Minnesota high school homecoming king and queen in black and white expressed the mood and the moment without the distracting element of color.

A Special Way of Seeing

BLACK-AND-WHITE PHOTOGRAPHY is a special way of seeing and recording the world around us. In a world of profuse and ubiquitous color, black and white provides clarity to form, poignancy to character, and timelessness to action. There is a special "otherness" to the black-and-white image.

It is not that I dislike color photography; I just approach it in a different way and for a different purpose. But black-and-white photography is my first and truest love. With black and white, you can cut to the chase. It allows you greater clarity: the ability to capture a person's character in his craggy face, to reflect the essence of a place through the play of light on landscape, or to record a timeless moment against a backdrop of action. Black and white distills the message; it helps you see through the camouflage of color to the essence of a thing, a person, or a place. It is timeless.

I've had a lifelong curiosity about this black-and-white world, a place devoid of color but nuanced by form, shadows, and highlights. My challenge has been to take the feeling and form of what I see and bring it through the photographic process to leave an image that can tell a story, illustrate an idea, capture a landscape, or express an emotion.

There is something clean and beautiful about a lone black-and-white image communicating directly from a printed page, a museum wall, or a family album. When I was writing the *Minnesota*

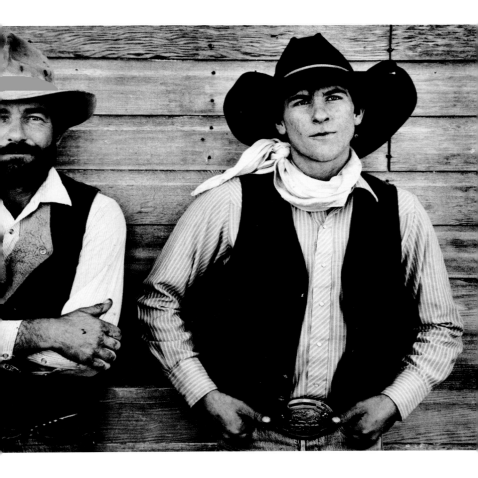

Travel Companion, I remember going back into the archives of the Minnesota Historical Society looking for photographs to illustrate the chapters. These beautiful old black-and-white images were so full of information and content that you never really asked, "I wonder what the color of his shirt was?" But the compositions, the information, and emotions contained in those photographs transcended time.

When I started my career as a photojournalist, nearly all my newspaper work was in black and white. And while I look back on some of that work

I used diffused light and the interesting texture of a Nebraska barn for this father-and-son portrait. I tried several exposures on the 4x5 before I captured the right expression. Lighting, composition, and working toward that certain mood makes this a successful portrait.

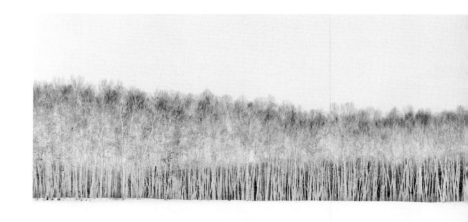

A stark treeline of birches in northern Minnesota is slightly overexposed to enhance the tonality. The expression of landscape in soft delicate tones is one of the strengths of black and white.

with a more critical eye than I had at the time, I am still struck by the agelessness of the subject matter. The cars and clothes may have changed, but the photographic content has not.

I was fortunate to have started working on a large daily newspaper, the *Minneapolis Tribune*, before they needed a daily dose of color. We weren't saddled with the need to put someone in a red shirt on the front page, or to consider if the yellow in a picture clashed with the banner color. The newspaper even took to running many of my landscapes of the Midwest as visual relief from the daily grind of news from Vietnam. It was during those early newspaper years that I developed a profound respect for the power of the black-and-white image, even as the lure of color was upon us.

Eventually I left the daily demands of newspapers and continued my black-and-white work with

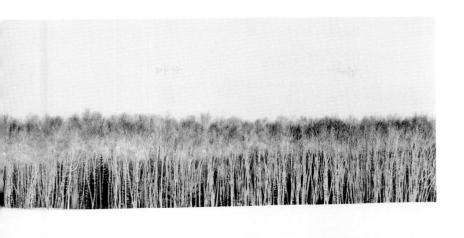

a 4x5 field camera. I drove the Midwest making photographs for an art calendar. Ironically enough, it was the portfolio of these black-and-white prints that made its way to NATIONAL GEOGRAPHIC magazine and started my career there as a freelance photographer and then as an illustrations editor. I was weaned away from black and white by the color needs of the magazine, yet to this day I still photograph in black and white and see it as an important continuing force in visual expression.

Whether you pursue black-and-white photography as a specialty in your career or as a hobby, a certain commitment of time, energy, and money will be required to achieve any level of journalistic or artistic success. My goal with this guide is to stimulate your curiosity and vision and provide information and guidance to help you develop your black-and-white photography.

A Brief History of Black and White

WHILE HIKING ON THE BARREN, rugged limestone mountains of the Snake Range in Nevada a few years back, I found large slabs of stones scattered by time, many with faint images scraped into them. They were carved by some lonely hunter recording images of running elk and buffalo. It struck me then, as now, that from the beginning there has been a uniquely human desire to capture or record the fleeting images of life. Some of the earliest human charcoal cave drawings, such as the ones at Chauvet Cave in France, date back 32,000 years. It would be thousands of years before humans developed the technology to take light and chemicals and fix an image to paper. But the desire to replicate an image has been ageless.

The story of black-and-white photography begins in 1839 with Louis-Jacques-Mandé Daguerre of France and William Henry Fox Talbot of England. They announced separately two exciting new processes that would revolutionize society's perception of reality. These processes became known as the Daguerreotype and the Calotype (Talbotype), respectively.

These two men were capturing, on metal and paper, moments in time held forever on a medium that could be hung on the wall or placed on a table. The timing couldn't have been better, as Americans and Europeans were ready for an easier and more accurate way to record their lives and their surroundings. "How charming it would be if

Henri Cartier-Bresson

it were possible to cause these natural images to imprint themselves durably and remain fixed upon the paper," said Talbot.

Initially the Daguerreotype was more popular, although it was an irreproducible positive image applied on metal. But though Talbot's process was accepted more slowly, it soon became the foundation for all future photography. He taught us how to take a negative image and apply it to a chemically treated paper to create a positive print.

Though these processes were cumbersome and slow (Daguerreotypes could take 30 minutes per photograph), it was an electrifying time for artists,

Henri Cartier-Bresson, the "master of moment," used the fast response of the newly developed 35mm camera to make iconographic images of everyday European life. This image was taken in Alicante, Spain, in 1932.

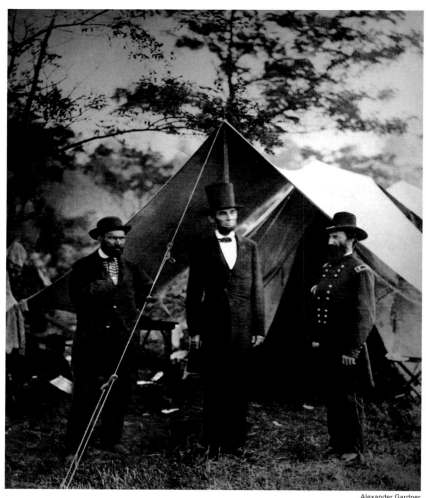

Alexander Gardner

Scottish photographer Alexander Gardner—an expert in the new collodion (wet-plate) process that was rapidly displacing the Daguerreotype—was on hand to record the tragic Civil War.

who could now create new images of their world, add reality to their vision, or create inexpensive portraits of their family and friends.

Interest in this photogenic drawing rapidly increased in the mid-1800s. Photography's ability to capture minute detail, especially in the Daguerreotype, added to its popularity. It became a craze, a *daguerreotypomanie,* as these gentlemen spread out to photograph landscapes, buildings, or

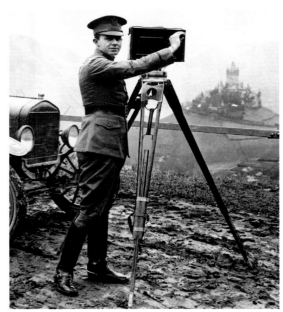

2nd Lieut. George E. Stone

The U.S. Army developed the Signal Corps in 1860. One of its missions was to record military events. Large bulky field cameras, such as this one used in Germany in 1919, have evolved into the very compact digital cameras of today.

anything else that didn't move too fast. Photography's capacity to deliver tone and detail, especially with large-format black-and-white photography, fascinates us to this day, and photographs still provide the emotional resonance that captivated the public when the process began over 160 years ago.

The time arrived when the ordinary person with a camera began to apply artistic treatment to mundane scenes. The American scientist Samuel Morse started working with Daguerreotypes in the mid-1800s. Studying under him was a young apprentice who would soon become famous for his photographs of the Civil War: Matthew Brady.

Brady's attention to tone and detail and his control over his subject matter from vision to print drew many converts to photography. The new medium had arrived and there was no turning back. The tangled avenues of expression of many early famous and not-so-famous photographers form a fascinating history.

Making Some Choices

Whether you want to explore the universal human experience, make landscape photographs that will find their way onto gallery walls, or simply record your family's journey with an album, you will need to define your goals.

After more than 160 years of photography and advances in technology and equipment, black-and-white photography is not an easy choice to make. We live in a world of abundant color, where the many hues and deep color saturations camouflage our subjects. Is there really any black and white out there?

Choosing black-and-white photography over color requires some soul-searching. What is drawing you to black and white, and how can you satisfy that curiosity? It is important to consider first what you want to do with your photography and how you want to approach the process before you decide what equipment you need.

Once you have chosen black and white, there is the difficult choice of whether to use a digital approach or traditional film, which further affects investments in a digital or wet darkroom. There are many positive reasons for choosing one or the other. I know many successful photographers doing incredible work using both approaches. In the end, it is their photographic vision that leads them to their choice of format. The recent shift from the traditional film process to digital photography is not unlike the shift from wet-plate to nitrate-backed film, or the shift from Speed Graphic to 35mm cameras. Each group of photographers has struggled with change.

Photography wasn't even considered part of the art world until fairly recently. I find it ironic that some people in the world of fine-art photography consider digital photography as somehow "less artistic," when it is merely a change in process, not

The front and back tilts of the large-format camera help keep image sharpness from foreground to horizon. Interesting weather or light can make for a strong landscape image.

vision. The debates will always be there, but your
vision is yours alone.

On one level, black and white photography
appears very simple, but it's a big leap from expos-
ing and composing that image to making a master-
fully printed black-and-white image that others
will want to look at or even purchase. Let's begin
by exploring some of the concepts of black-and-
white photography that might help you in your
choice of tools.

Vision and Visualization

Your double challenge is to capture your image in black and white and to master the technological process to turn your conception into an artful photograph. One without the other is like a story without an ending. Your vision, your story, needs to be poignant and compelling, but without a way to give it visual form, you're only halfway there.

This photograph, popularly known as "Migrant Mother," has become an icon of the Great Depression. Taken by Dorothea Lange in 1936 for the U.S. Farm Security Administration, it captures in black and white the despair and determination of a migrant worker and her children.

To me, the vision part of this equation is the most difficult. Let's step back a moment and talk about what makes a compelling black-and-white photograph. For example, you can tell yourself, "I only want to take pictures of my dog," and stop there. But go to a bookstore and look at some black-and-white books about dogs and you can see the different levels of visual intensity that some photographers achieve when they're simply photographing their dog.

You can see that there's an emotional level of visualization expressed by the way they use light, tonality, timing, and composition. The use of black and white brings an additional level of meaning or interpretation to the image.

It's hard to articulate what makes a great photograph. Yes, there are rules you should follow and, yes, be prepared to break them sometimes. But if I can sensitize you to certain elements that make a great black-and-white photograph, maybe I can prevent you from continually looking at your prints and wondering what went wrong.

First, here's my disclaimer. You can put down this book, break all the rules, discount your friends' advice, and push ahead on your own. Many great photographers have done just that, and in a sense that's what made them great. They had to do it their way or their interest would have quickly faded. They had to pursue their own vision and they had the innate talent to get there. For many others, it requires plain hard work.

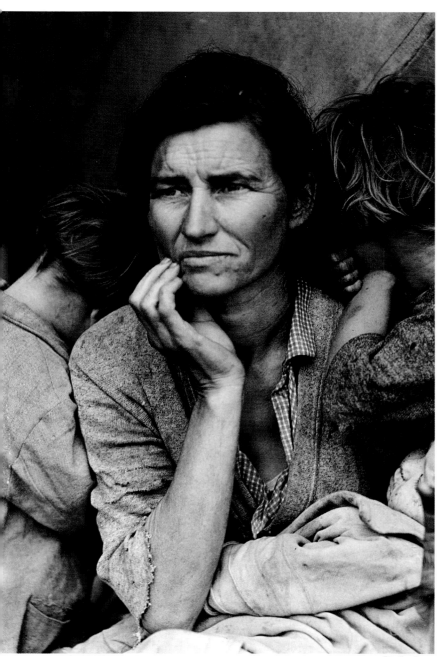

Dorothea Lange

I remember showing a small portfolio of my black-and-white Greenwich Village work to my professor in Minnesota, and he asked, "So who are you copying?" I wasn't copying anybody, just nosing around New York with a Yashica SLR camera photographing whatever interested me. My instincts were leading me, and that has always paid off. My advice is to follow your gut.

This book's main purpose is to show you how

The deep shadows and strong lines add to the "tough" mood in a Minneapolis inner-city school. Tri-X and a lightweight 35mm camera are the tools of the "street photography" part of my work. I use high ASA (ISO) settings because they can yield more contrasty and grainy images.

to strengthen your own visual expression in black-and-white photography while helping you pick the right tools to get you there.

The Internet is loaded with technical talk and you can get lost in this techno-babble. There is a lot to learn and research on the Web, but the best way to learn is to just get out and make pictures. Use this guide to get you through some of the difficult spots.

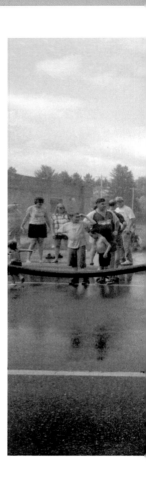

TODAY, THE VISUAL SIMPLICITY and poignancy of black-and-white photography feels more powerful than ever. Advertising campaigns use black-and-white images to recapture the attention of a color-saturated audience. One cannot deny that most of the time-honored and remembered photographs are black-and-white images. Today, many fine-art photographers continue to work in black and white, a genre that a large part of the art-buying market favors.

The ability of the black-and-white photograph to strip away the unnecessary and concentrate a message through form, shadow, and light provides its inherent strength and power to communicate. But without the rich palette of color to hide behind, you must have something to say when you use black and white to express yourself. And although you need to practice the art and mechanics of black-and-white photography, I encourage you to be spontaneous and intuitive—a "just do it" kind of photographer.

The Black-and-White Subject

You will soon need to make some tough decisions about cameras, printers, and digital or traditional darkroom tools. But first you need to understand what visualizing in black and white means. To begin, you need to ask yourself what motivates you to make a photograph. Why are you tending towards black and white? If you find yourself wishing you had a camera for every

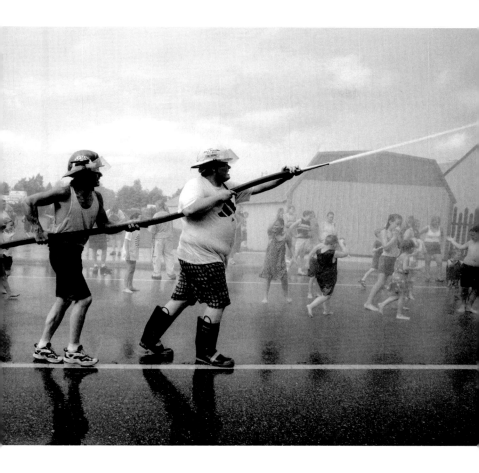

golden sunset, or if you only desire to photograph the fall colors in New England, maybe black-and-white photography is not right for you.

The power of great photographs of landscapes or portraits speaks to something deep, something lasting that goes beyond the color. If you go to some distant hill and look out across the expanse and see the play of light on the fields or hills, and see the patterns of grasses or the glisten of the backlit road that cuts to the horizon, you are seeing in black and white.

Let's discuss a few of the elements that go into

This photograph of a 4th of July water fight from my book *In Search of Lake Wobegon* is an example of an instance when a black-and-white moment can be more dramatic and make a different statement than a color image.

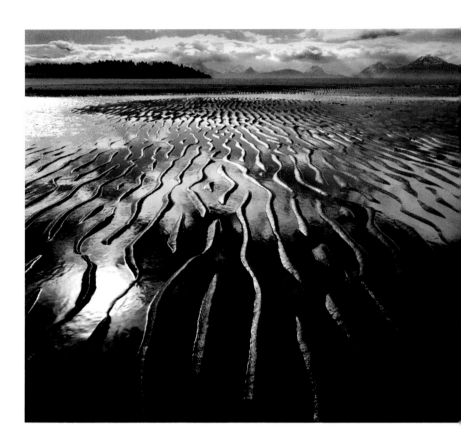

A field camera with tilts helps with perspective control. Here it enabled me to maintain focus from a few feet away to the horizon.

a successful black-and-white photograph. First, the image always reaches beyond the obvious color you perceive. Color most often doesn't work as an image when transformed to black and white. I can explain this by looking at Ansel Adams's photograph of the Tetons and the Snake River. A color photograph of this scene, though beautiful, might end up as only another pretty landscape. But Adams's approach, devoid of color, moves us through layers of light and shadow enhanced by active weather. His black-and-white work evokes deeper feelings than a pretty scenic photo does. The goal here is to create energy in your photography that goes

beyond recording a place you happen to visit.

Let's use my photograph of Katchemak Bay, Alaska, as another example. I could have made this a color, 35mm photo in a fraction of the time it took me to hike out in the Bay and set up my 4x5 view camera. But I had visualized this as a black-and-white image about clouds, mountains, water, and sand, where light from the vertical pattern on the sand contrasted with light from the horizontal clouds.

Some Rules of Composition

You should know that landscape photography is one of the most difficult genres to master. You never want to boil down your approach to photography to a set of rules, but there are few principles to keep in the back of your mind to help you organize your vision and try to go beyond just another pretty picture. First and foremost, think about what you are trying to portray. Is it the grandeur of the mountains, the quietude of a stream, or the character of a place?

Rule of Thirds

A photograph needs strong compositional elements to make it interesting. A photograph is most pleasing if you follow what photographers call the rule of thirds. This requires that you visualize your composition in a grid of thirds, from top to bottom and left to right. Then place the most important element of the photograph at one of the intersections of the grid rather than in the middle of the photograph. With a landscape photograph, for example, you can keep the horizon from running right across the center by keeping it low or high in the photograph. If it's a street scene, place the subject off to the left or right a bit and see how the composition feels. This also works well with portraits and architecture. You want to create a bit of tension by placing elements

in unexpected parts of the image or slightly off center. The bull's-eye effect tends to be boring. Instead, let the subject lead the eye into the photograph. That being said, go ahead and break the rules sometimes—most pros do.

Leading or Converging Lines

Strong leading lines or converging elements in a photograph can help a lot. Fences, roads, trees, curbs, and houses are just a few of the elements that can help pull the viewer into the image or provide a compositional direction to your scene.

Foreground and Background

Many great photographers use foreground and background layering to achieve strong compositions. Wide-angle lenses can help by accentuating elements in the foreground, while a diminished background still provides the necessary support. Working in close with a wide-angle, especially

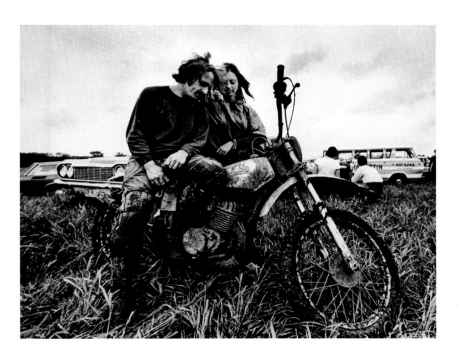

The clarity and composition afforded by a large-format camera effectively enhances this Iowa scene (opposite). The gritty feel of 35mm coupled with overcast light helps express this intimate moment after an off-road race (above).

with people in a street scene, can give an edgy, in-your-face feel, while still capturing the elements of the street where they live. Continue to look at how you can play foreground and background off against each other. Selective focus with a telephoto can also isolate a foreground element, allowing a soft compositional element to provide the backdrop.

Dramatic Sky or Weather

When the clouds are swirling, a heavy fog is forming, or a snowstorm is brewing, get your camera bag packed and go out to where you think there might be a good photograph. A marina full of

boats on a sunny day is not very interesting to me, but an early foggy morning or a raging blizzard, well that will give me an exciting day's shoot. It seems that black and white really excels when the weather or light is iffy. If you're shooting film, don't forget to bring a yellow filter along to help with accentuating the clouds on a sunny day.

Form and the Black-and-White Photograph

Form is about composition and what gives structure to your print or image. Form is the design and depth you bring forth from the scene that is needed to enhance the subject and give it presence. Just as architects use their vision to give form to walls and a roof, which may produce a shopping mall, the Guggenheim Museum in New York, or the Sydney Opera House in Australia, so do photographers apply different levels of form. How you see and form the physical world within your compositions, how you use your lenses and apply your unique visual perspective to your subject, will determine how successful your photograph will be.

There are rules, but the sooner you hone a visual sensitivity that comes naturally from within, the less likely your photographs will be mechanical and predictable. Your vision and your use of content and form will become your signature. Some photographers apply their compositions in harsh contrasts and bold designs. Others have a softer touch, allowing the subject to speak in muted tones. Some prefer to work their subject and forms in the harsher style of street photography. The gifted photographer finds some order and form in a visually complex world. Here are a couple of pointers that may seem obvious but are often overlooked.

Fill the Frame

One of the biggest mistakes amateurs make is not using the whole frame. Don't rely on cropping to make up for a lack of imagination or just plain laziness. Use all of the elements we have talked about, and fill the frame with them. Selective focus, strong leading lines, and foreground and background placement will all be working for you if you complete your composition by filling the frame. This often requires changing lenses or, more likely, changing your location.

Vantage Point

Many times the only difference between a good and bad photograph is the photographer's choice of where he or she takes the picture from. Many people never leave established roads and trails; some never get out of their car when they drive through a national park such as Yellowstone or Glacier. You can never expect to make good strong photographs unless you expect to exert a lot of energy. Be prepared to hop a fence, cross a road, knock on a door to ask permission to drive somewhere, or ask the local park ranger to keep the gate open a little longer so you can work the golden light. Trails can lead you to a vantage point that most other people are just not going to reach. You'll also be amazed how a little smile and a reasonable request will be rewarded. Just be sure to deliver any prints you've promised.

Compose Boldly

This is a catch-all for "shoot now, think later." Let you inner feelings take control and experiment with angles, vantage point, and exposures. You have nothing to lose. I was always told by my editors, "film is the cheapest part of this whole process." For those shooting digital, you have no excuses about the cost of film. So let your imagination take you where it may. You

Tip

Without using your camera, practice looking at how form, light, and composition can be applied to enhance your subject. Will waiting for the right light or weather help your photograph?

FOLLOWING PAGES:
Skull on post, Santa Fe, New Mexico.

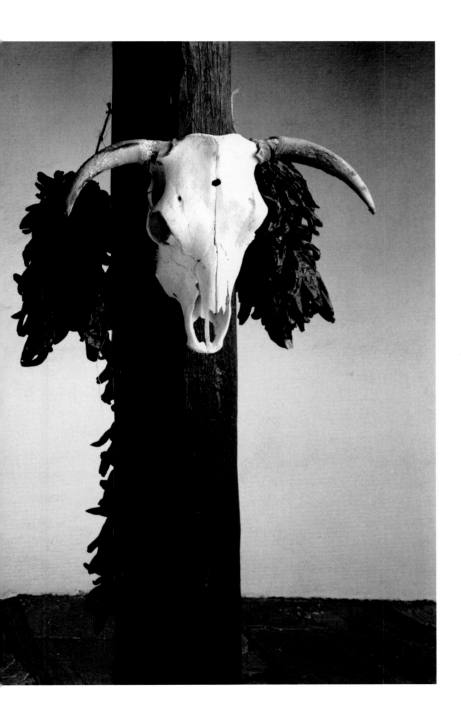

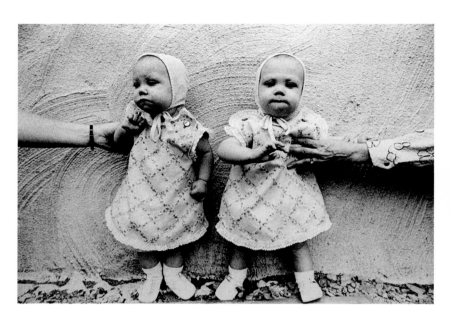

Making photographs at a local Minneapolis gathering of twins, I seized on the idea of a stark image. Hoping for that special moment is what makes documentary photography so appealing. It's expecting the unexpected.

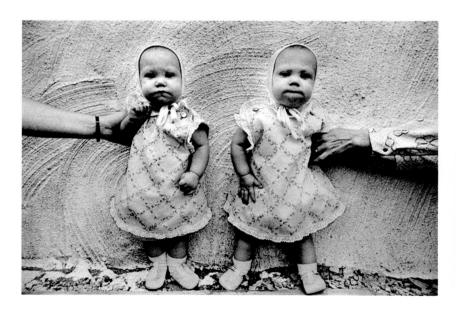

may never drive down that road again when the light is just right or the situation is perfect. Don't ever say you'll shoot it on the way back. It will never happen.

The Moment

This is one of the most difficult elements of photography to describe. What is this moment we talk about? It is not about composition, yet it is. It is not about a special light, yet it can be. It is about a feeling that emits from a slice of life and is captured by a camera in a fraction of a second to live on forever as a decisive, authentic moment. Henri Cartier-Bresson (1908–2004), a French photographer known for his unique vision and oblique reportage, coined the phase, "decisive moment." He described it as the ability to capture a fleeting moment in which the subject's significance is expressed in content, form, and expression.

But what is that exactly? There are no rules or templates to follow, for that would defeat the purpose of developing your own vision. Finding the moment is nothing more than finding your eye. This means developing sensitivity to content, form, and expression in the world you see, and exposing a frame when these special elements come together as you see them. You and others will know when that happens. Trust me, it doesn't happen just by walking out the door and looking for a moment. Moments happen by living your life with your camera.

Moments can happen in a heartbeat. They most often happen when the subject is unaware of your presence or when you've finished photographing and everyone relaxes. It can be a beautiful landscape that suddenly takes on a special moment when the light changes, a cloud passes, or an object enters the frame. Many great

Try to work in extreme lighting conditions, as I did with this full-moon time exposure of an abandoned South Dakota hotel. It can help you make that mysterious and unusual image.

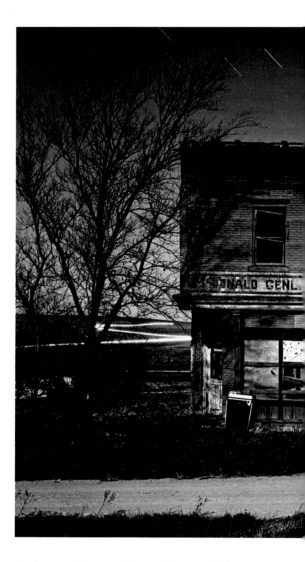

landscape photographers will set up their camera and wait for something, anything that can help bring forth a special moment.

Moments can most often be found by looking into something rather then just at something. What do I mean by looking into something? This is difficult to describe, but maybe it is simply

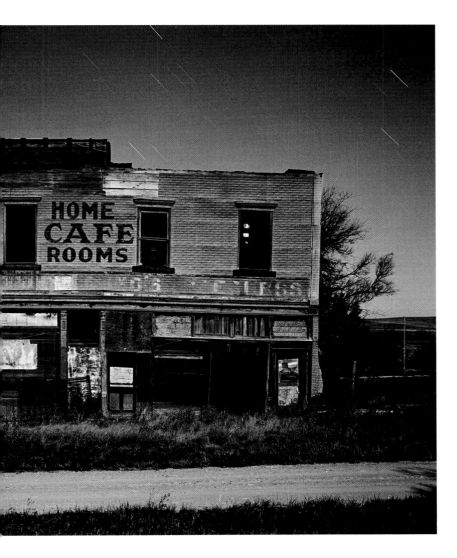

photographing what you feel and care about.
If we really knew the rules there'd be no challenge
to this thing called photography. All I know is
that working in black and white provides some-
what of an advantage in searching for moments,
and that's because we're working with fewer dis-
tracting elements.

Light and the Black-and-White Photograph

Light is the most obvious and essential element required for making a photograph. Form and subject can be lacking in your composition, but without light you haven't got an image. Light, and how you use it, makes the elements of subject and form come together. Without an understanding of lighting, either natural or flash, you will not be able to make very interesting black-and-white photographs.

The most difficult part of the equation is to bring all these elements together in a seamless blend or layering. I'll use the term layering a lot, because in the digital world, imaging programs allow you to work in layers, whereby certain elements of a photograph can be worked on in different sections or layers. It's like burning and dodging in traditional darkroom jargon. But layering in terms of subject, form, and light is the skill a photographer must build to bring everything together for a successful photograph.

Waiting for or using a special quality of light will enhance the tone and subject of your photo. Is there moody or inclement weather, a gauzy fog, or the cutting light of a late afternoon sun? For example, a north window provides side light on an old friend's face and body as he leans forward, elbows on a table, holding a cup of coffee. It's a simple image, but with dramatic lighting, his portrait can be rich and compelling. With wonderful window light creating shadow and form, this photograph expresses something unique about the man.

Simple Rules for Avoiding Bad Light

There are some fairly common rules that photographers should follow. One is to avoid photographing in high-noon sun. It's contrasty, harsh,

and most often unpleasing light to make pho-
tographs in. Overcast days provide a less contrasty
light. Black-and-white photography is more pleas-
ing and easier to print when it's done in open
shade or on cloudy days. There may be times
when you want to break these rules, but generally
speaking, if you're looking at a photograph that
just doesn't work, notice what kind of light it was
shot under and maybe you'll understand why.

As I've said, working in the early morning and
late afternoon can yield some nice light that
exposes lots of detail with long shadows that are
not as deep as high-noon shadows. People photo-
graph better under light that comes in low and not
from above, and low light also gives more pleasing
skin tones. And the color you see will most likely
transcribe nicely to black and white.

If you decide to use flash, bounce the light off
the ceiling or a nearby wall; never use direct flash.
Some street photographers, however, choose to
use direct flash because of its harsh effect. Another
approach is to use a bounce card taped to the flash
and pointing straight up. Most of the light will
bounce up to the ceiling, yet the card will reflect
just enough light forward to bathe a nearby sub-
ject in a small fill of light.

If you're doing portraits, use soft north-win-
dow light or use a soft-box to soften the strobe
light. A soft-box is a simple box of translucent
cloths and baffles sewn together to sit on a stand
and allow a strobe's light to be softened and dif-
fused much like north-window light.

Whether you're shooting landscapes, people,
or architecture, the single most import step in
making a great black-and-white photograph is to
see your subject as a strong compositional form,
stripped of its color and exposed in an interesting
quality of light. Remembering this will enable
you to create a beautiful print that others will
want to look at.

MARION E. WARREN
Documenting a Region

M. E. Warren

AFTER MOVING to the Chesapeake Bay after World War II, M. E. Warren began to document the transformation of the Chesapeake Bay and its communities from a sleepy maritime area to a world-class yachting and tourism center. His most famous and sought-after photographs recorded the local scenery, harbors, skipjacks, canneries, and oyster dredgers before they became preservation projects. His black-and-white photo of a moonrise over the Chesapeake Bay Bridge, probably his most popular photograph, has been compared to Ansel Adam's famous photograph known as Moonrise over Hernandez. With over seven books to his credit, at 84 Marion still works in his darkroom daily to print his favorite images from a 60-year career.

"As a young man, I had a chance to sit down with Edward Steichen, one of the icons of 20th-century photography, to have my portfolio reviewed. He flipped through it pretty fast until he came upon the print of the dancers in St. Louis. Before he got up and walked away, he said, 'Young man, if you continue to take pictures like that, you'll be a great photographer some day.'

"I wasn't too sure what made that image so great, so I apologized for not having a really good camera. He said, 'There isn't a photographer alive

While on assignment for the Navy in 1945, M. E. Warren took a short Thanksgiving holiday in Paris only to have days of fog. "I could hardly see, but that's what made this image of the Eiffel Tower so appealing. Without that one boy and the people and the ghostly elements of the tower, I wouldn't have had a photograph. Sometimes in a photograph, less is more."

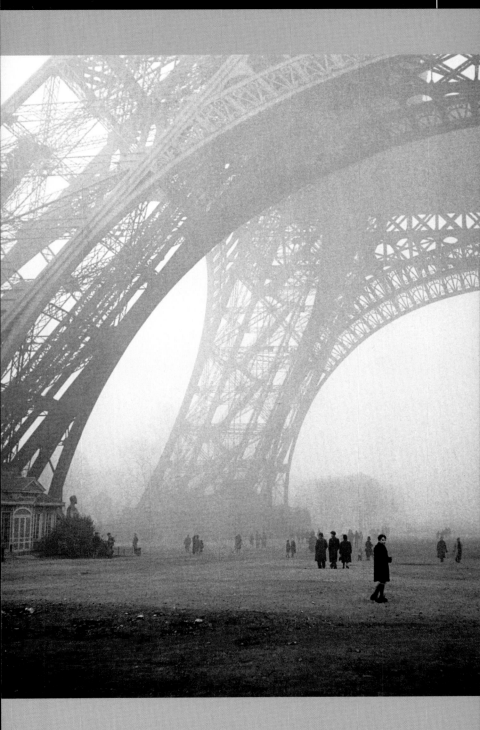

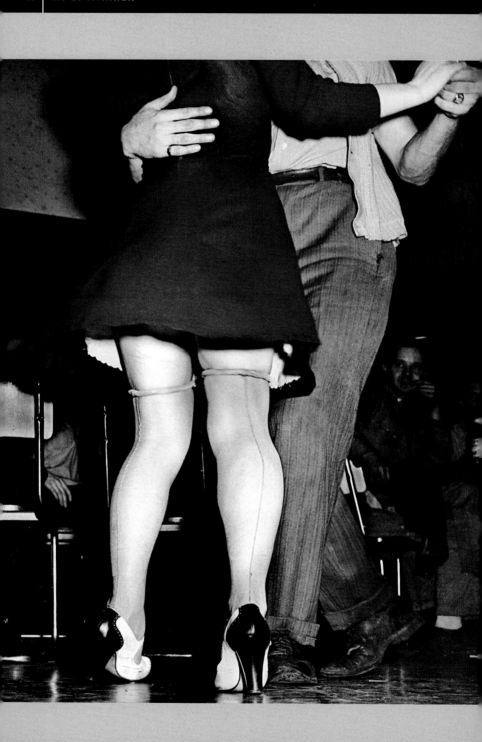

who could even make full use of a simple box camera.' That has stuck with me forever. It's what you see and how you see, not what kind of camera you're holding, that makes the difference.

"I got interested in photography back in high school. When I saw my first image come up in the dark room… well, I've never turned back.

"I had gone to a one-room schoolhouse up to the eighth grade and when I went to a bigger school I felt unimportant and overwhelmed. It wasn't until I started taking pictures in high school that I felt like somebody. The pictures weren't very good, but I was the best they had and I really liked it when they recognized me as the school photographer. I graduated in 1938, during the depression. It was tough finding work, but I was determined to be a photographer. I kept pushing and I always found a way to work.

"For a few years I worked around St. Louis in various studios and in a hospital where I started working in medical photography with 8x10. All this time I was learning about composition, lighting, and chemistry.

"I really fell in love with the photography life. On weekends Wally, the darkroom man, and I went out to look for photos. One day we saw these horses and the clouds and I made that photo. I was 20 years old. Looking back on some of those early prints I still think many of them are as good as anything that I have done up to today.

"While on assignment, I always found a way to make some pictures for myself. I always shot what the client wanted, but I'd also shoot a few photos my way and they ended up picking a lot of those instead. It really started to build my confidence.

"I once worked for a professor in St. Louis. The most important thing he taught me was not to look just at the light on a subject, but to study the shadows. That's where the good photographs are crafted; learn to paint with shadows. I never took a

"I was with a friend at a St. Louis tavern's Saturday afternoon jam session; it was 1941. It was one of those times where carrying my Speed Graphic paid off. I saw this couple really kicking it up, doing the jitterbug, so I set up the camera low on the floor and pre-focused on a spot. This was the image that really caught Edward Steichen's eye a few years later when he reviewed my portfolio."

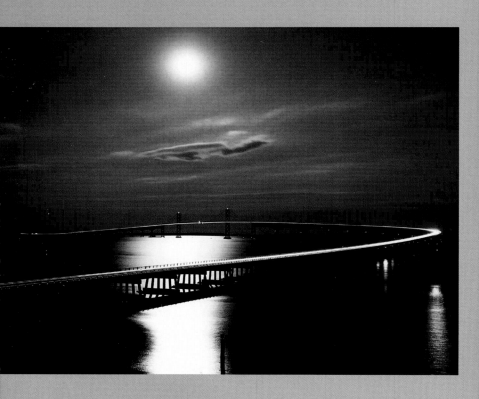

"I had visualized the image I wanted of this new bridge spanning the Chesapeake. There was only one day when the moon was correctly positioned or I'd have to wait another year. I timed the exposure for the four minutes it took a car to cross. I even stopped down the camera as the car rounded the curve to keep it from over-exposing the image."

picture after that where I didn't study the shadows more than the highlights.

"I started doing work for the Associated Press as a wire photo operator. But I wanted to make more money and have a little adventure, so I enlisted in the Navy and ended up in Washington, D.C., assigned to the Secretary of the Navy's office photographing important dignitaries.

"I think the wonderful thing about photography for me was, if I got tired doing one type of photography, like corporate or promotional photography, I would turn to something else, like architecture. I ended up working for some very famous architects and then *Fortune* magazine started to use my work, and things kept growing.

"I'm 84 and still working in the darkroom today. I have never tired of making prints. Many

times I'm so excited about printing a negative that I can't wait for it to dry. I really never liked color because I'd have to turn my color over to somebody to print and it never came back like I wanted it. Even in the new digital photography you have more control both in black and white and in color than we had early on. I am having my Bay Bridge photograph printed in the new carbon inks and I think it is as good if not better than what I was printing from the darkroom.

"I still think black and white is a strong art form and will continue to be. You are not distracted by the color, you can paint with the light and composition and not have garish colors taking away from the subject. When I did the book *Bringing Back the Bay*, there was a lot of pressure to do it in color. My test was to go out and see if I could do a sunset photograph in black and white that was strong. Well I did, and it was just beautiful, so we decided I could do the book in black and white. I feel it makes my work more timeless."

M. E. Warren Tips

- If you see a picture out of the corner of your eye, stop then and take it, don't tell yourself that you'll come back and take it. It will never happen. Work when you feel it; do it now.

- Photographing people is like doing wildlife photography. You have to ease your way in and gather their trust. They mustn't feel threatened.

- Use whatever camera fits the job. If it's spontaneous and fluid, then stick with 35mm. If you have control of the lights or lots of time to work on a composition, then use a view camera on the tripod.

- Include as much information as possible, so there is something for the viewer to digest in your photographs.

- Photographers need to adapt to these new tools. You have to keep learning.

- Most of my black-and-white people pictures were not taken from behind the camera. I would always be off to the side, waiting to catch people when they didn't know when I was going to push the shutter. My idea was always to try to pull the real person out in the photograph.

WE ALL DESIRE the latest cameras, lenses, and supporting gear like filters and tripods. That makes walking into a camera store a dangerous event if you haven't decided exactly what you really need. I have shot many stories for NATIONAL GEOGRAPHIC magazine with a manual camera, a 24mm, and a medium telephoto lens. I know many photographers who have shot incredible stories with a small Leica and a 35mm lens. The phrase "less is more" is really apropos, and I adhere to it.

By now you've put some thought into what you want to achieve with your photography, and it's time to choose the right equipment to help you down the challenging path of black-and-white photography. There are many books and Web sites to help you with highly technical details and camera specifications, so be sure to learn about up-to-date equipment and models. The scope of this guide is to pose questions and help you make the right choice about camera format.

Most important, your camera choice depends on your subjects. Simplicity and size favor the 35mm camera, whether digital or film. Medium- and large-format cameras are well-suited to grander subjects that require preparation time, such as landscapes and portraits.

All cameras are basically alike. There's a lens on one end that focuses an image on the opposite side of the box. The amount of light reaching the film or digital chip is controlled by a shutter and a diaphragm. The shutter controls the amount of time the light is allowed to reach the film or chip,

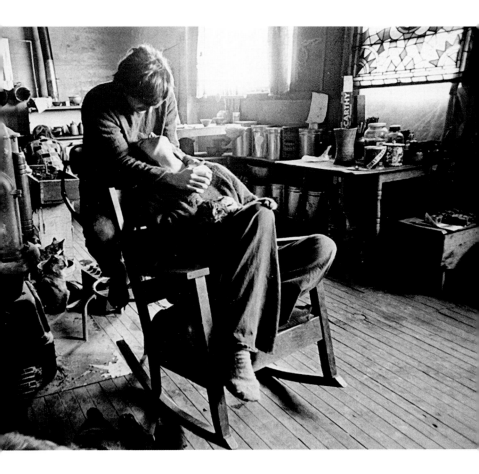

and the lens diaphragm controls the amount of light to pass through. A smaller f/number denotes a wider aperture, and a larger f/number denotes a smaller aperture: f/2 is wide open, f/16 is narrowed way down. Think of the iris of your eye as the same as the lens diaphragm. In low light your eye's iris will be wide open, like f/2 on a camera. Blinking is like the shutter, you can do it fast or slowly. It's this combination of shutter speed and iris openings that exposes your image on the negative or chip.

Inexpensive point-and-shoot cameras give you little control over these basics, while cameras

Spend time with your subjects so they become comfortable with you and your camera, as I did at this farm in western Minnesota. Use a camera that allows you to respond quickly to those fleeting moments.

costing hundreds or thousands of dollars give you the full range of exposure control and lens interchangeability. Whether you use 35mm or large-format, you want a camera that will give you control over your exposures and compositions. A well-exposed and composed negative is the basis for your final effort to make a wonderful print.

A Word About Lenses

Before we look at the various camera formats for your black-and-white photography, I'm going to make my most important point on the subject of equipment: the camera lens is the place to invest your money. The old bromide, "You get what you pay for," is a safe rule to follow in buying a lens. In black-and-white photography, image quality is paramount. Sharpness, contrast, and speed are the major considerations in a lens, and getting these qualities does not come cheap. While most of us might balk at buying the really expensive super "fast" lenses with maximum aperture settings of f/1.4 or f/2, the reason for shooting with 35mm is speed and flexibility, and a fast lens is a great asset that will help you in low-light situations. If you want to work with wildlife, you will need the fastest telephoto you can afford. But landscape photographers who like to work from tripods usually stop down the lens to f/11 or more, so a fast lens is not necessarily their main consideration. In either case, buy the best piece of glass you can afford, stick with the major manufacturers and avoid deals unless you really know what you're doing.

I recently spent a painful amount of money on a 40mm lens for my Hasselblad. After seeing the beautiful contrast and resolution of the images from this camera, I know that I will use this lens through the rest of my career. The pain of the purchase is behind me, but I still have this lens by my side.

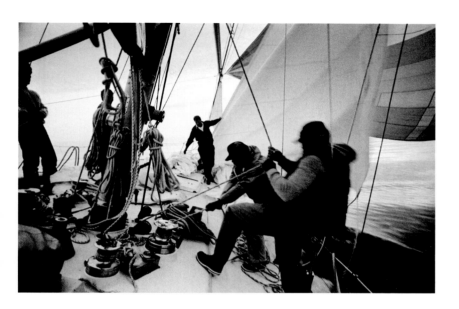

35mm Cameras

In 1905 Oskar Barnack, a development engineer at a German microscope company, Leitz, had an idea to reduce the size of the negative used in bulky large-film cameras and use enlargements of it to make prints. He took 35mm movie film and used its 24x36 mm format for his new lightweight camera.

It wasn't until 1925 that Leica mass-produced a 35mm camera. It opened the door for lightweight, highly portable photography and ushered in a new breed of documentary photographers such as Henri Cartier-Bresson, Walker Evans, Arthur Rothstein, Edward Steichen, and W. Eugene Smith, to name a few. Though many early photographers continued to work with larger-format cameras, this new, more spontaneous type of documentary photography brought forth a strong vision

Only 35mm film or digital cameras offer real flexibility of movement and involvement with an active subject. Be sensitive to the layers of activity and tone that can make for an interesting image.

My Leica yields some of my best images. Its light gathering capabilities and sharp resolution, coupled with strong sidelight, produced this striking portrait of a Basque shepherd on a Montana sheep ranch. I spent two days with him gathering his trust before the images started to come together.

that influences photographers to this day.

In 1936 a German company introduced another revolutionary camera, a camera whose viewfinder showed exactly what the lens was seeing. It was the pioneering Kine-Exakta, a single lens reflex (SLR). And in 1949 the German camera maker Zeiss-Ikon developed the Contax S, the first un-reversed image in a pentaprism viewfinder. The Nikon's F series SLR was introduced in 1959 and became the serious photojournalist's camera of choice.

In deciding whether to use 35mm rather than larger format, you should consider how quickly and unobtrusively you want to work with your camera. Journalism, street photography, wildlife and back-country photography, and sports photography all require mobility and functionality. And an additional complication is whether or not to go digital. The world of digital has fully engulfed 35mm, and sales of traditional darkroom materials and 35mm film cameras have dropped dramatically.

With the introduction of the full 24x36mm digital chip and the array of image-stabilized lenses that allow for low-shutter-speed, hand-held photography, you'll get little argument from me about going totally digital. Many photographers who have embraced digital photography are doing wonderful work with more artistic control than any photographer before has experienced. To be sure, there will be photographers working with film for the foreseeable future. There is no right path, just your path.

The Rangefinder

The rangefinder, like the Leica M6 or M7, is still one of the sweetest, lightest, quietest cameras on the market. The lightweight Leica continues to be the instrument of choice for many of the world's great photographers. It uses film, and the famous Leitz optics will deliver some of the sharpest

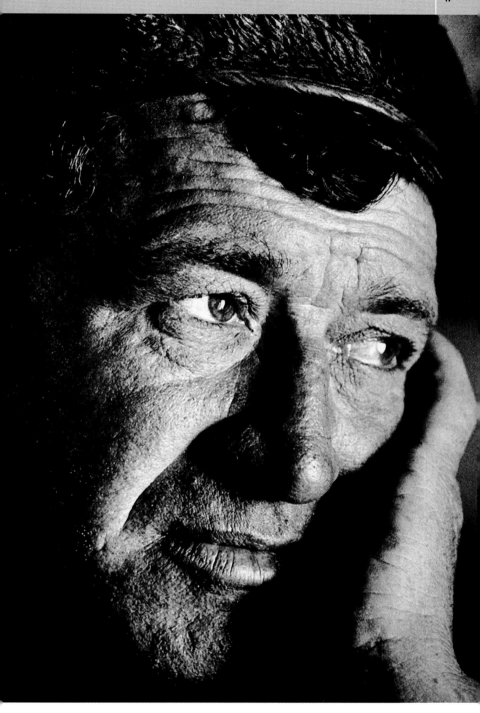

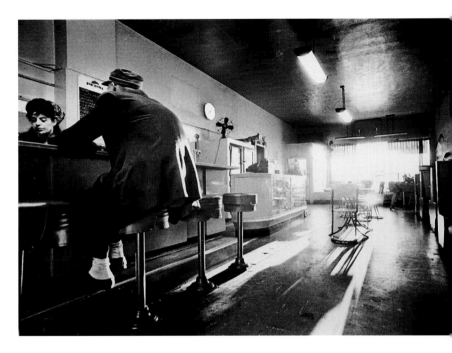

Always keep a camera with you for those moments you can never prepare for. My Nikon SLR helped me instantly see and compose this moment.

images you will ever get in 35mm. For many people used to the single lens reflex, the subject doesn't feel as dynamic in the rangefinder's viewer, but the simplicity and light weight of the rangefinder allows you to carry it with you wherever you go. The other advantage of a rangefinder is the ability to focus under extremely low light levels. A SLR can be very difficult to focus in a dark room. Even auto-focusing SLRs can get confused in these low-light situations. Also, keep an eye out for new rangefinder digitals by Leica and Epson. Untold numbers of Leica's famous M-series lenses have been left to gather dust on a shelf by those of us who have switched to digital. A digital solution that uses these lenses will be incredible.

Single Lens Reflex (SLR)

The single lens reflex camera has the most dynamic viewing and focusing system available. With the image passing directly through the lens and reflected into the viewfinder, you can see exactly what will be in focus and composed when you push the shutter. Today's modern SLR, with every imaginable combination of exposure and film advance control, is truly a technological achievement. Image-stabilized telephotos allow for hand-held photography at very low shutter speeds.

Digital SLR 35mm

The high-end digital SLR is deceptively similar to its old film counterpart. But in my experience this is a fantastic new tool for working in color or black and white.

Digital SLR cameras are now firmly established, especially in the world of newspaper photography. The changeover was like the move from Speed Graphic to 35mm. Anybody who didn't make that adjustment was left behind. But for many in the fine-art world, greatly enlarging or digitally printing images can still be difficult with 35mm digital files. I have compared full 24x36mm digital images with 35mm transparencies that I've scanned on an Imacon scanner and printed both up to 30x40. To my eye, the image resulting from a scanned film printed big has a more pleasing, film-like quality than an image shot on a digital camera. The larger inkjet prints (20x30) from digital 35mm still have a slight edgy look, and when you compare them against large-for-mat film or digital, well, they just don't stand up. The point is, digital photography is here to stay, and black-and-white photography will continue to play an important part in this mix even though digital 35mm has a few challenges to overcome.

There are still directors of art galleries and museums and serious collectors who are skittish

about this new technology and the inkjet prints. Change is difficult, even the venerable NATIONAL GEOGRAPHIC magazine continues to value the traditional 35mm slide, but this too is changing as they now begin to publish digitally photographed stories. The quality of the new full-frame 35mm chip is making any arguments against the digital process rather pointless.

If you decide to step into the digital 35mm world, your workflow process will be dramatically shortened on the front end of shooting, but lengthened on the processing part. You can shoot a digital 35mm image, bring it into the computer to color balance and tweak contrast and saturation, and then e-mail proofs or put them into a layout. That's the quick part. But there is more work managing the data files in this digital process. Mixing chemicals for black and white, processing a roll for several minutes, drying the negatives, and printing an 8x10, may seem rather simple compared to working with all the levels of software, computer savvy, and image management of bits and bytes. Yet artistic control has never been more in the hands of the photographer. There is no gain without a little pain. Don't expect to master this overnight.

Medium-Format Cameras

For all the flexibility of the 35mm camera, there is a price to be paid with the size of the negative or digital image. So much marketing is directed toward 35mm that some young photographers don't even know about medium-format cameras. The medium-format camera, which uses 120 or 220 film, has a 6x6-cm image size or 2 $1/4$ -inch-square negative. There are also variations of this size, but most have at least one dimension of 2 $1/4$ inches.

The obvious advantage of the medium-format camera is the negative size, nearly four times larger than that of a 35mm negative. The real difference is what you see when you scan a medium-

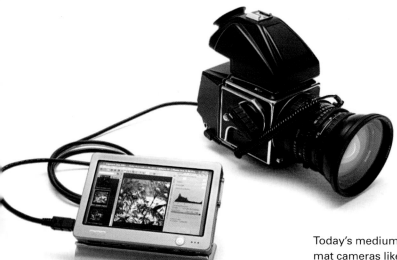

Today's medium for-
mat cameras like the
Hasselblad and the
Mamiya can adapt to
digital backs that either
are self-contained or
connect to the new
palm-sized PCs. The
image and color reso-
lution are wonderful.

format negative and make a print. There is no
question that the medium-format camera gives
greater detail.

A photographer who is interested in high image
quality with greater detail and a larger print should
consider a larger-format camera. Once again, think
about what you want to photograph. If your pas-
sion is landscapes or close-up photography where
detail and texture are your goal, bite the bullet and
go big. If you want to have gorgeous prints hanging
in a gallery, or you want to sell 40x40-inch prints to
a client, this format will not disappoint you.

But there are drawbacks to medium-format
cameras. They are heavier and slower to work with,
the lenses are slower, and the cameras themselves
can be expensive. Hasselblad, Mamiya, Pentax,
Bronica, and Fujifilm all make various medium-
format cameras from 6x6cm to 6x9cm and come
with an assortment of extremely high-quality
lenses. I use my Hasselblad as a handheld, and
though it's a bit more work, I'm much more
enthused with my landscape work in medium for-
mat. This format is a little like taking out the heavy
artillery. Sometimes bigger is better.

Medium format offers a much larger image area that can be square in proportion, which is preferred by many fine-art photographers. It also gives you the opportunity to crop your image either vertically or horizontally.

Digital Backs

Now here is the exciting and confusing part. There are digital backs that can replace the film backs on the Hasselblad, Mamiya, and others, ones that produce an extremely large digital file. The interesting thing here is that we have reached a time when the old film format size doesn't always compare equally to digital size. Canon has come out with a 16.7-megapixel 35mm chip that is equal to some of the earlier 16 megapixel backs made for medium-format cameras. Digital is definitely shaking up the camera world, and every month some manufac-

turer is upping the ante with a new product. Chip sizes and resolutions are changing too. Use the Web to do your final research on what's out there.

One important thing to keep in mind about investing in a digital back for the medium-format camera is that these backs can be used on other cameras and adapted to certain 4x5 view cameras. I feel somewhat protected from all the constant upgrading in digital 35mm cameras because my digital back can migrate to new cameras and also allows me to switch out the back when I want to shoot with film. This versatility between film and digital was a major selling point for me.

Be aware that some of these medium-format digital backs need to be tethered to a small computer, although the trend is toward self-containment. I have been working with a small notepad computer from Acer and a Phase One H 20 digital back connected to my Hasselblad, and it feels no more burdensome than carrying a small camera bag over my shoulder. And now there is an ultra-personal computer that runs Windows and fits in the palm of your hand. Be warned, however, if your goal is to be a casual amateur on a budget, this is a big step. But if you're a prolific shooter, you can justify a bit of this expense by the savings in film costs and workflow ease spread out over several years. Regardless of the economics, color and black-and-white photography is incredibly beautiful in this digital medium format.

Large Format Cameras

My passion and income from photography began on newspapers and moved to NATIONAL GEOGRAPHIC magazine, where the 35mm format is the workhorse. But I have always had a love affair with the image quality of the large-format camera. For black-and-white landscape photography, there is nothing that can compete with a 4x5-inch negative. Whether you print that negative the

Tip

Invest in a fast and sturdy tripod since many interesting black-and-white compositions can be found during the twilight hours when form and design are enhanced by back-lit situations. Handholding a camera for longer then a 60th of a second exposure is only for the steadiest hand.

traditional way, or scan it digitally and then print to inkjet, you will see the difference in image quality from 35mm or even medium format by a country mile.

But it's a big step to large format. A professional has many things to consider when buying equipment, and most settle on a system that is practical for the type of work they do. For amateurs to maintain a 35mm, medium-, and large-format arsenal is financially unrealistic, unless they have a rich uncle. Add in the rapidly changing digital components and they had better keep their day jobs to pay for all of it.

There is much research to do before choosing a large-format camera. They come in several sizes and designs: 4x5, 5x7, 8x10, and beyond. There are field cameras that are made of lightweight materials and fold up for a backpack. There are others built for a life in the studio. For much of this discussion, assume that I am talking about the smallest 4x5 format.

Why go to the bother and expense of shooting black and white in large format? There is no doubt that it is cumbersome and can slow you down considerably. But once you make your first big print it is like a window to another world. The detail and depth are so rich you can almost step into the photograph. You might say fine, but really wonder if it's too slow to get anything other than static landscapes or portraits. Well, my answer is, your own energy and imagination are the only restraining factors.

Here's a case in point. NATIONAL GEOGRAPHIC magazine contracted me to do a story with National Public Radio personality and Lake Wobegon creator Garrison Keillor. Keillor had been writing and speaking about this fictional Lake Wobegon for more than 25 years, and the goal was to return to Minnesota

This Arca-Swiss view camera is all metal and also accepts a digital back. The tilt and swing perspective control of the finely machined 4x5 provide a real experience in image-making.

The 4x5 view camera is the camera of choice for many serious landscape photographers. Its front and back can tilt relative to the the plane of the image, which can help control difficult depth of field.

and see if there were any vestiges of this mythical place remaining. I convinced the editor and director of photography that I could do the story in black and white with a 4x5 field camera. Black-and-white photography would better capture the timeless feel of a mythical place, whereas color would give it too much reality.

It was the scariest thing I have ever convinced myself to do—to shoot a story with a 4x5 from a tripod. But after a few weeks on assignment, I had a system worked out that required only a few seconds to set up the photograph. Instead of showing the editor the final shoot in the typical slide-show

format, I digitally scanned and printed these large-format photographs for the editorial team to review. I had shot a story in 4x5, black-and-white photographs for a magazine that was dedicated to color and 35mm. In addition, after the story was published in the magazine, Keillor and I also published a book.

It was one of the most rewarding projects I've ever undertaken even though I spent most of my nights loading sheet film holders in the motel's darkened bathroom.

Don't limit yourself and your view camera only to static subjects. I have photographed many people situations with a lightweight view or field camera. The results will have amazing depth and detail.

View and Field Cameras

Large-format cameras produce negative sizes that are 4x5, 5x7, 8x10, and larger. But the predominant field camera is the 4x5. It is the most versatile, and its negatives are the easiest to develop and print. Processing is slightly more involved than with medium format and 35mm and also requires a 4x5 enlarger, lenses, and adequate darkroom space to work with the bigger prints.

Then there are view cameras and field cameras. View cameras are traditionally made for studio work and can execute a wide range of front and back swings and tilts to control depth of field and perspective. They are mostly crafted of metal, and some, such as the Arca-Swiss, can be broken down and packed for airline travel or the trunk of your car. The exposures are controlled by the shutter and iris contained in the lens. The lenses are rather slow, and you are required to work under a focusing cloth with an upside-down image on the ground glass. And trust me, you wouldn't want an all-day hike with a metal view camera and tripod unless you have a strong assistant.

There are a number of collapsible lightweight field cameras to choose among. It's amazing what you can stuff into a backpack for an off-road photo shoot.

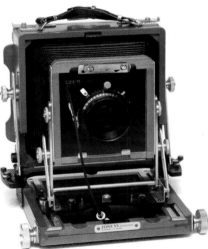

As the name suggests, the field camera is for "location shooting." It is more often made of wood, is much lighter, and, most important, it is collapsible. The trade-off is that fewer camera movements are available, and the camera is not as structurally rigid as the metal view camera. That can make a big difference if there is a wind shaking the camera and tripod. But the field camera can be closed up and, with careful packing, stuffed in a backpack. Now you can hit the trail, but don't forget your tripod (a must), film holders, and focusing cloth. Again, this is where it is nice to have a willing friend along.

Whether I'm working with a view or field camera, I never tire of their functional beauty and the swings and tilts that can give the depth of field I desire to the foreground and background. One of the great advantages a view camera gives you is the ability to control the perspective and depth of field when shooting buildings and landscapes. Be patient; with a bit of practice you will soon be accustomed to working with the controls and composing with an upside-down image on the

FOLLOWING PAGES: With a 4x5 on a tripod, an afternoon spent chasing Minnesota spring rock-pickers finally paid off. The image has tone, detail, composition, and, luckily, moment.

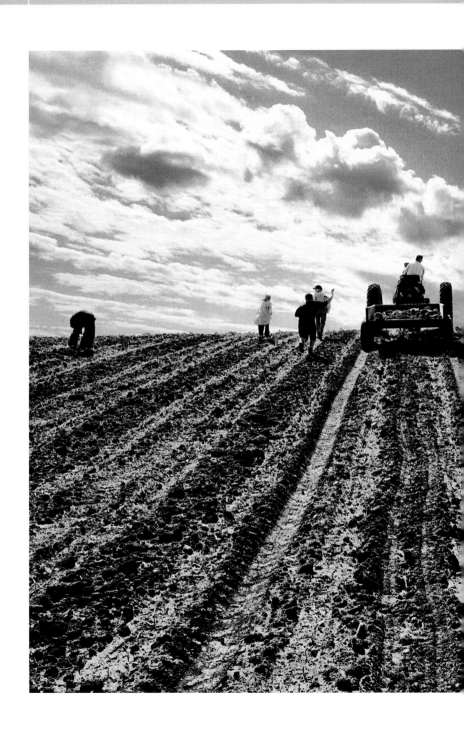

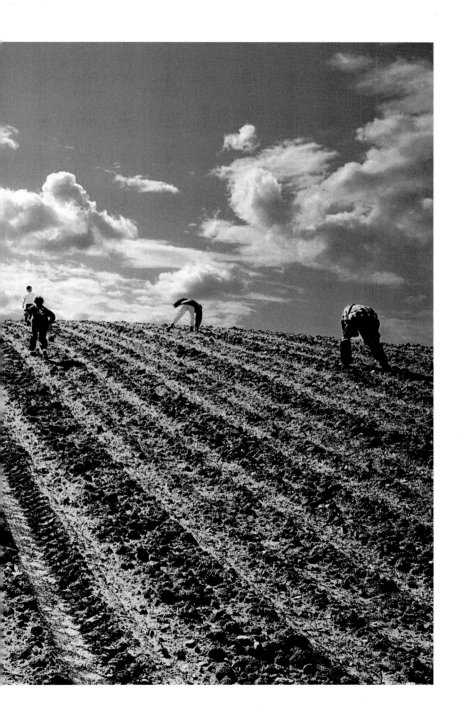

glass screen. The rewards of making a successful image on a 4x5 are beyond words. The image size of a 4x5 negative is 15 times the surface area of 35mm, and an 8x10 negative is 60 times, so the final photograph will have unbelievable detail. Many photographers will simply make contact prints from the 8x10.

Film comes in cut sheets, and you need a changing bag or darkroom to load the sheets. There's a special notch on the film to make sure you load it with the emulsion side facing out. I know it's obvious to say that your film-loading room must be dark, but you'll be amazed if you allow your eyes to adjust for a few minutes how many light leaks there can be. One disadvantage of sheet-film holders is that you usually don't load enough. You need to budget your exposures to avoid running out of film during a shoot, or you'll spend some irritating times with your hands in a changing bag. (A changing bag is a light-tight cloth bag in which you can load film in daylight.) There are backs for view cameras that hold Polaroid sheet film for viewing the exposure and composition so you don't waste a lot of film bracketing your exposures. But here's the hidden advantage of having limited film to use; you actually begin thinking about what you're shooting. It's amazing how slowing down the photographic process a bit takes your work to a more thoughtful stage.

Digital and Large Format

The digital world has been available to large-format studio photographers for a while now, but recently Phase One, Leaf, Imacon, and Sinar offer digital camera backs that can adapt to 4x5-inch view cameras such as the Arca-Swiss. But only strong finely machined, metal view cameras can manage the added weight of the special tooling for adapters and backs. The payoff is that you are allowed all the camera movements that a view

camera affords but on a 4,000x5,000-pixel file.

Before you jump into large-format digital, have a talk with the manufacturers of both the digital back and the camera to make sure there are no compatibility issues. Even though the digital backs will continue to change and hopefully come down in price, your investment in your view camera will be protected. The camera will never go out of date. You need only upgrade the digital back and you've got a new camera.

This melding of large-format photography and digital image acquisition is now allowing photographers to accomplish what was difficult or impossible in the past. Modern digital backs will allow a new generation of photographers to rewrite the rules on what is possible using a camera system whose invention predates the past century.

This digital image shot during a snowfall on the Chesapeake's Eastern Shore has so much detail that a 30x50-inch print still holds wonderful image quality.

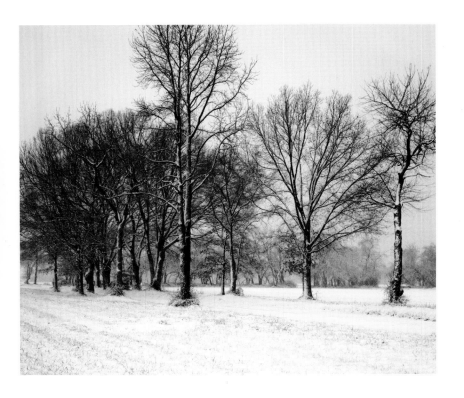

WE HAVE COVERED some of the decisions that go into making black-and-white photographs and we've discussed choices about cameras and lenses. Now you face the remaining challenge: to combine the technical issues of making a good exposure with the esthetics of making a strong visual statement. Your objective is to artistically transfer values of light, with all their various shades and tones, through your camera to your film or digital file.

Even with automatic features, mastering all the technical aspects of higher-end cameras will require time. Once you have worked through these complex choices you will be able to make wonderful black-and-white photographs. One of the most important prerequisites for making beautiful photographs is an understanding of the relationship of light to image.

Simple Facts About Light

Taking a photograph requires light, any kind of light, but enough light to make an exposure. What might not be obvious to the beginning photographer is that the quality and character of light can make the single most important difference between a so-so photograph and one that takes your breath away.

If you are experienced with color film, you know, for example, that the warm tones of an evening sun will shift the color values on daylight color film to a warmer palette of mauves

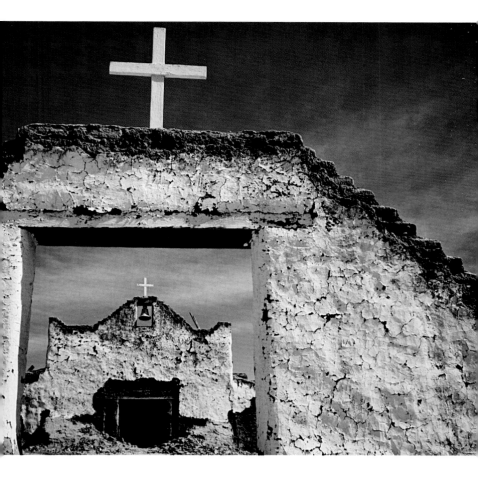

and yellows. And the cool blues of a foggy morning can enhance the mysterious moods of a wetland landscape, if you understand how the combination of film and light can be played against one another. The same holds true for black-and-white photography even though the results are subtler. Your objective is to consistently interpret how the quantity and quality of light shining on your subject will affect the film or digital image on your camera and the resultant black-and-white print.

The play of light, the contrast between wall and sky, and the levels of subject come together in this New Mexico image. Each day, every nuance of weather, every landscape composition offers new ways of self-expression.

Using Light to Your Advantage

During those golden sunset hours, the sun's rays have to travel through more of the Earth's atmosphere to light your subject. The longer wavelengths of red and yellow pass through the dense atmosphere, while more of the shorter blue waves are filtered out. That is what gives us those beautiful warm-toned sunsets in a softer more diffused light. That is why you see so many great black-and-white and color landscape photographs taken during early morning or late afternoon hours. The photographers are working the more diffused and softer light. The low angle of the sun gives more shape and contour to the landscape. You'll soon discover that shooting at high noon or on sunny afternoons will yield high-contrast, difficult-to-print photographs, whether color or black and white.

Your understanding of your film or digital camera's capabilities, combined with your artistic judgment, will enable you to make that special photograph.

But first you need to understand how black-and-white films differ from color films. Even though you might be shooting with digital, you still need to know these basics. Remember, the main objective in converting a color scene to a black-and-white image is to increase contrast between two colors, which, in black and white, have nearly the same shades of gray.

Most black-and-white negative films are more sensitive to blue and less sensitive to reds. That is why the light on a beautiful blue-sky day exposes the sky with more density than the rest of the scene. When you go to print the film, you end up with a featureless white sky because the blue sky exposed the negative with added intensity. The eye compensates for these visual nuances in real-time color, but black-and-white film needs help with fil-

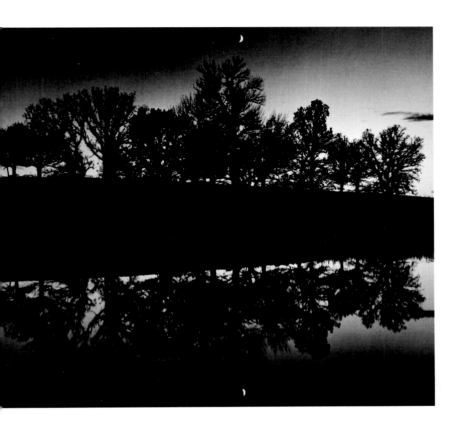

ters or digital balancing to achieve consistent results. A yellow or red filter will remove much of the blue and not expose the sky so densely.

The same thing happens when you photograph a bowl of apples. Film is less sensitive to red, therefore red apples in the scene register on the film with less intensity. So when you go to print the negative, the apples appear darker than you wish. A light blue filter will allow more red to pass, giving your negative a higher density, so when you make your print the apples won't appear so dark. If you take the photograph digitally, you have the option to convert the color to black and white later, using a combination of the color channels or other aids to adjust contrasts and tones to your taste.

Early morning or late afternoon can provide a photographer shooting in black and white with many graphically interesting situations such as this moonrise over a Minnesota lake.

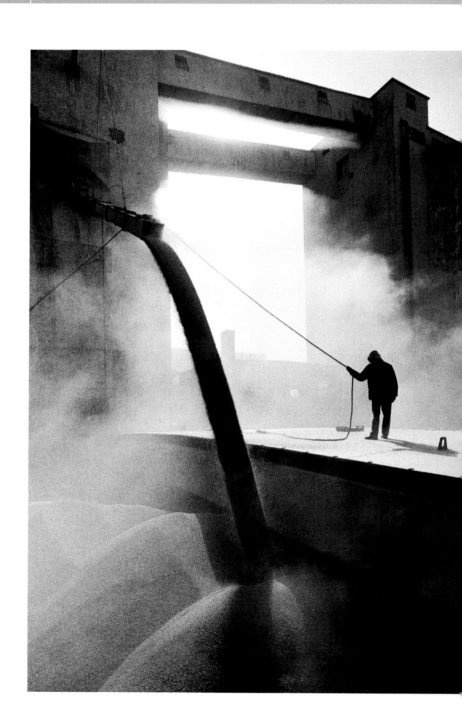

The technical issues concerning light, filters, and tone can seem confusing, but a little effort on your part in this area can make the difference between ordinary images and great photographs. There are many books and Web-based resources about filters. Adobe Photoshop also offers imaging options to help you make contrast enhancements to your black-and-white photographs.

Always remember that a black-and-white photograph is a stripped-down version of reality. You are working in only two dimensions and various shades of gray. We are going to explore the following key concepts: quality of light, contrast and tone, texture and shape. Understanding these concepts can help make your images worthy to hang on the wall.

Quality of Light

No single element in making a photograph can affect its outcome more than the right light. What is the right light? It really is up to you to decide. But your awareness of how the quality of light can affect the impact and mood of a photograph is the biggest step you will make in black-and-white photography.

Direct Sunlight: Yields high contrast, harsh and deep shadows, and strong over-exposed highlights. Direct sunlight can be very difficult depending on the subject. Many landscapes will be too high in contrast and unappealing at high noon; a desert scene, however, might be helped by high contrast and deep shadows. An edgy street scene might be better in this harsh light, while a moody portrait would not. It is amazing that just waiting for that late-in-the-day sun or softer light can change the entire appeal of a photograph.

Overcast Light: The middle tones of a subject are allowed to live in the diffused, less harsh light of an overcast day. The range of tones between pure white and pure black is where the beauty of

With the black-and white-image, graphic and bold designs can be enhanced by back-light. Sometimes the most difficult lighting situations bring out the best mood and the strongest design. Break the rules, shoot into the sun.

Tip

Use the Internet to keep abreast of the fast-changing digital photography industry. A simple keyword query in your area of interest will help you avoid expensive mistakes like buying outdated or discontinued items at the local camera store.

FOLLOWING PAGES: Keep your horizon line away from the center of the photograph, and make good use of foreground-background relationships to help illustrate an idea or tell your story. Be daring with your composition.

black-and-white photography thrives. In photographing under a flatter light, you can work the subtleties of your subject to your liking. Having a full tonal range on your negative or digital image allows you to change the contrasts (to your liking) when you make your prints. A good example is a forest floor covered with fallen leaves on a cloudy day. The negative has the full range of tones, which would have been destroyed under a full sun. But later, in the printing process, I was able to bring up the contrast enough to give a strong tonal and design element.

Open Shade: In the absence of shade, working in the shadow of trees, buildings or anything that takes you out from under the harsh sun can bring you a wonderful quality of light for portraits or anything else that might be rendered unprintable in high contrast.

Inclement Weather: When it's best to stay indoors, that's when it's best to be out taking pictures. Many photographers find that misty, rainy, snowy, windy, or foggy days open up all sorts of photographic opportunities. Working the extremes of weather and using the special quality of light it affords should be a motivator for the photographer in black and white.

Contrast and Tone

Whether you're using a traditional darkroom to develop black-and-white film or a computer's digital editing software to convert your color images (more on that on page 122), contrast and tone are your strongest tools to achieve impact with your black-and-white photographs. Contrast is the degree of difference between dark and light values of your subject. A sharp dividing line between the sunlit highlights on a face and its deep shadows is an example of a high-contrast image.

Tone is the overall lightness or darkness of a

Contrast and tone are the hallmarks of an interesting black-and-white photo-graph whether it's strong window light cast down on a elderly man being evicted from his apartment or the spatial light inside a modern office building.

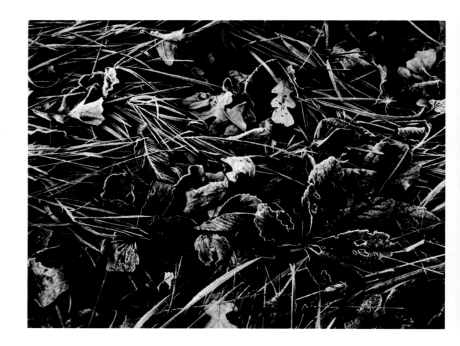

subject. For example, a foggy landscape will have predominantly light tones and low contrast and is often referred to as a "high-key, low contrast" image. A darkened room with a small light on a table will be predominantly dark and is called "low-key," even though it might be high in contrast. Just remember that contrast and key are not the same. A photograph may be high in contrast yet have low key or dark tonal values overall. Many accomplished photographers use extremes of contrast and tone to make their memorable images.

Shape and Texture

Shape and texture are two of the great strengths of black-and-white photography. The ability to strip out the color and use lighting that enhances the overall visual design and texture of the subject can have dramatic visual impact. You can

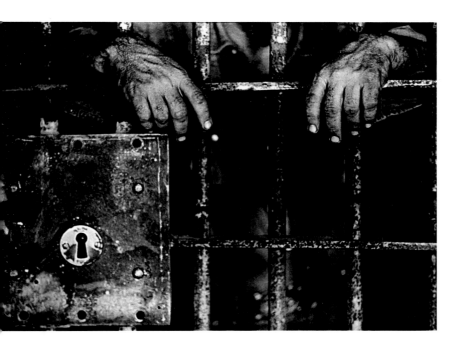

Providing contrast to enhance the shape and texture of your subject can be achieved by working with light and exposure. The frost on the leaves and light from the jail's window bring important highlight details to these photographs.

make your statement by using lines and shapes. Any image can be made stronger by forcing the line, shape, and texture qualities in black and white. A black-and-white image with all of the above elements, beautifully printed, matted properly, and framed handsomely, is a work of art!

So let's summarize. Search out good light. Search out the images that have good contrast, mood, tone, and shape. Use filters to enhance your subject, remembering that a filter of a certain color will lighten the tones of that same color on your subject. Watch for interesting highlights and shadows. Work those golden hours, either late in the day or early in the morning where the light is soft and is casting interesting shadows. Now have fun,

DON DOLL, S. J.
A Call to Service

Ken Blackbird

FATHER DON DOLL has been a Jesuit priest for 35 years. For much of that time, he has used the power of the photograph to interpret, teach, and explore the lives of those he was called to serve. His work on the tough and sparse conditions of America's Indian reservations has created a moving body of work that spans three decades. Father Doll continues to teach journalism at Creighton University in Omaha, Nebraska, but still travels the world photographing the human stories that support his spiritual calling. His black-and-white work has appeared amongst the color-filled pages of NATIONAL GEOGRAPHIC magazine, and Kodak honored him in 1997 with the Crystal Eagle Award for his photographs of Native Americans.

"As a youth I didn't really have an interest in photography other than taking cameras apart. I never had any film or anything, but I was fascinated with all the parts. So it really wasn't until I was ordained and teaching at the Rosebud Indian Reservation that I was asked to take some pictures for a brochure and then asked if I'd like to learn more about photography. Well, at first I was terrible, and the camera they gave me came from a rummage sale. But the principal of the school had an expensive Leica 35mm locked in the safe, and after nearly three months of pestering, he let me use it.

"This was a story I shot for NATIONAL GEOGRAPHIC magazine: Athabaskans Along the Yukon, February, 1990. It was very difficult to work inside a culture that kept to themselves, and it took time to gain trust. Because of my lifelong work with Native Americans, I had an understanding of their customs and what was acceptable in

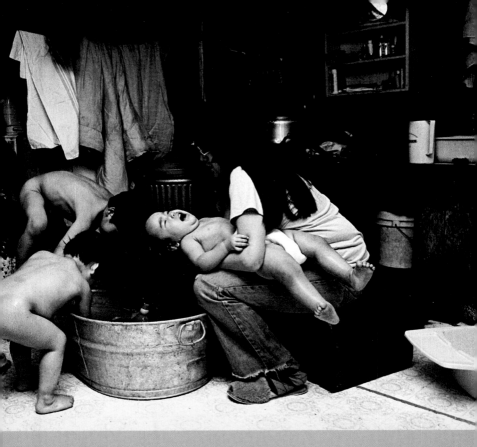

my role as a journalist. The use of black and white and a little bounce flash along with my lightweight Leica helped make this intimate moment possible. For me, black and white is a very strong tool for social statement."

"I was 25, and it took me a year to figure out what I was doing. The chemicals we used and the film were bad, so I was getting no results. I began reading about photography and took a summer photojournalism class in Milwaukee from Pat Moran of the *Milwaukee Journal*. He was ruthless, from the old school, and he really pushed me into learning. There really is something to be said for someone helping to lead the way.

"Back then color was out of reach, so much of my early work was only in black and white. Eventually I began to love the black-and-white image and understand its power to communicate. I loved the way black and white abstracted things, the way it got down to the bare essentials of life with form

"What can be said about the low-light, high-contrast portrait of James Holy Eagle, who was 102 when I made this image. Holy Eagle was born the year of the Wounded Knee Massacre and became an activist and story-teller in his later years. I shot this with a Hasselblad and a 120mm lens with a half-second exposure. It later appeared in my book *Vision Quest*."

and emotion. I really love the fall season out here on the plains when the leaves begin to drop and the prairie sheds its summer coat. That's when I can really feel the black-and-white qualities come out, and it continues all the way through winter. Color can distract, and for many years you could not get me to shoot color. I really wanted to keep to the essentials as I began recording the life of the American Indian.

"The interesting road of getting a black-and-white story into NATIONAL GEOGRAPHIC magazine began when I was on the faculty of the Missouri Workshop with Bill Garrett, Associate Editor of the magazine (later to become editor). He asked me if there was anything I wanted to do for the magazine. I told him that I was going up to Alaska to work with the Yupik, an Inuit people. He said, 'Why don't you shoot that for the Geographic?' I said I didn't want to work in color and he said, 'That's okay, just do it in black and white.' That was the beginning of my association with National Geographic. I think Garrett had a real appreciation for the black-and-white story. When the Yupik story came out in 1984 a lot of photographers took notice that the Geographic would do a black-and-white story such as this.

"*Life* magazine's story of New York's Needle Park by Bill Eppridge in the late '60s and Eugene Smith's story on mercury poisoning at Minamata, Japan, in the early '70s were real eye openers for me. The fact that other photographers had the ability to do these amazing social documentaries in black and white, when the whole world was embracing color, was rather important.

"Black-and-white photography is not about moving a print from the developer to the fixer, it's about picking the right tool, the right medium for what you're trying to say. And back then, color was too expensive and didn't fit the subject matter the way I thought black and white did.

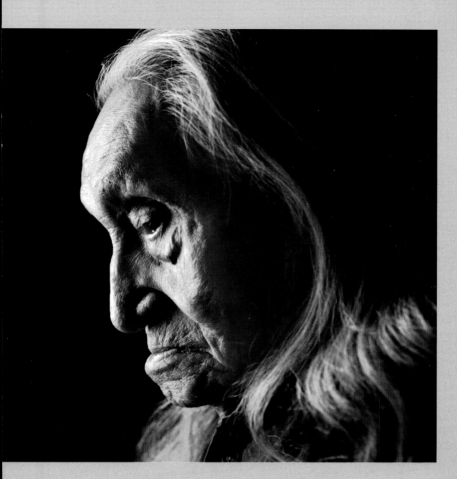

"A good example of how the darkroom process
can get in the way surfaced when the Geographic
sent me up to Alaska again to do another black-
and-white story on the Athabaskans, an Indian
nation that lives along the west coast of Canada
and Alaska. I started doing darkroom work up
there and giving prints to the people I was pho-
tographing. This helped to open them up a bit, but
I was spending all my time in the darkroom and
not interacting with the people. You need to master
the technical, but get beyond it as quickly as possi-
ble and move on.

"Like many photographers getting into black and white, I fell into the whole Ansel Adams thing, making my own developers and trying to get half-grade contrast shifts with different dilutions. Sure, I think a full grasp of the darkroom can be helpful, but by the mid 1980s I decided to get out of the darkroom and let someone else do it. I really wanted to be out making images.

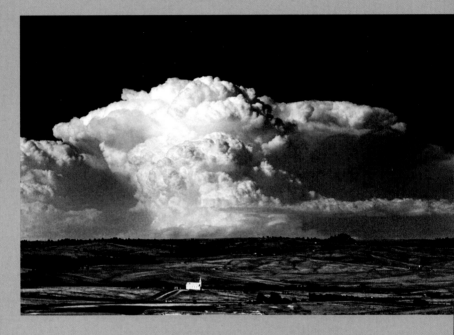

Storm clouds gather over the Wounded Knee, South Dakota, burial ground and church. Victims of the 1890 massacre by the U.S. 7th Cavalry are buried here in a mass grave.

"Teaching black-and-white photography is a big challenge now. Most everyone has shifted to digital, and it's hard to get black-and-white film processed unless you maintain a costly school lab. It's an ironic shift that black and white can be more expensive now than color. It's quite possible that the next generation of students will have very little exposure to black and white. The other day in class, I took a color image and removed the color in Photoshop. We had a good discussion about which of the two images was stronger. Interestingly, many felt the

color photo was stronger. Color continues to be seductive to young, beginning photographers.

"There is the digital solution, though. Students can now extract a black-and-white image with good contrast by choosing an appropriate channel or mix of color channels, or by using a Photoshop plug-in. They can take that to the new printers with pigment inks and get an incredible print. Many school art departments are still teaching traditional black-and-white darkroom photography and it will be around for some time, especially if you want to do large-format photography for gallery walls.

"I have my Leicas sitting on the shelf, and I'm not likely to put a roll of film into them and go out and make a picture in black and white when I can use my high-end digital camera and subtract the color in Photoshop. The tools have changed and new and established photographers have to take notice of this if they're going to survive. But whether it's digital or film, I will always love the pure simplicity of the black-and-white image."

Don Doll Tips

■ When doing portraits, try to steer your subjects so that "Rembrandt" light streams in on them from a window. Position yourself closer to the window so you are looking back at your subject at a 30-degree angle.

■ Put your subjects at ease by affirming them. Tease them into talking about their favorite things so they can relax and be themselves, forgetting that you are there with a camera.

■ When composing, try to envision your subject as shapes and scan the viewfinder's rectangle to see how they fit. Let your eye scan up, down, and across the frame, paying attention to the way shapes or objects enter or exit on the edges.

■ When approaching an assignment, make sure you are prepared. Get rid of every negative thought. Know your equipment. Don't use a new piece of equipment on a critical assignment.

■ Always follow your hunches on what to photograph, it's your only clue as to what you are interested in. It will ultimately define your vision.

I'LL NEVER FORGET THE COMMENT made by one of the photographers at the newspaper where I was working in Minnesota when I brought my new Apple II computer into the photo lab in 1983. "What would you ever do with one of those things?" he asked. I didn't have an answer, but 20-some years later that same photographer is sitting in the same spot downloading digital images from his camera where there were once sinks, enlargers, lockers full of film cameras, and lab assistants mixing up gallons of noxious chemicals. I'm not at all surprised to see how sudden and pervasive this move into digital photography has been. The reason for the sudden embrace of digital photography is simple: the control it affords over the image making and final presentation of the photograph.

With all the digital buzz, though, we need to remind ourselves that digital cameras don't take better pictures, computers do not add emotional content, and these new digital prints do exactly what silver-gelatin prints have been doing for a hundred plus years: communicate the photographer's message.

Whether you take your photograph with a film camera or a digital camera, in this book we will take your image into the digital realm all the way to a digital black-and-white print. We will look at this process in scanning negatives and transparencies, converting color transparencies or digital color over to black and white, and, finally, making museum-quality black-and-white prints. First, let's look at the equipment and workflow we need to carry us through the process.

The Necessary Computer Equipment

Most people today have a computer with enough raw power and memory to handle digital photography, convert to black-and-white images, and make prints. But here's a list of the right tools for those of you who want to seriously pursue black-and-white digital photography:

1. A computer with at least 256 megabytes of memory (RAM) (1 gigabyte of memory is ideal) and a relatively fast processor, in the 2,000 GHz range. I favor Macintosh, as do many in the graphics industry, but PCs are

The ability to take a picture in the morning with a black-and-white C-41 type film, process it at the local lab, and have prints, scans, and proofs ready in a hour is indicative of the powerful tools available to today's photographer.

cheaper and have more software available.
2. A CD or DVD burner on the computer, and
FireWire or USB connections for external hard-
disk storage. Also, an external hard drive (125
gigabytes or bigger) for backup and storage.
3. A good CRT monitor, at least 17 inches, or a flat-
panel screen (LCD) of the same size or bigger.
(see "Calibrating Your Monitor" later in this
chapter). Do not scrimp here.
4. Photoshop or Photoshop Elements software. I've
been working in Photoshop for over a decade
and in my mind this is the one you want to cut
your teeth on. Do not panic when you see the
manual and accept a steep learning curve with
Photoshop. You don't have to learn it all, just
what you need. Get help with an instruction
book.
5. A good-quality film scanner for those who are
going to shoot film.
6. A good-quality inkjet printer by Epson, Hewlett-
Packard, or Canon (with pigment inks). There
are others, and prices vary depending on paper
size. Many busy photographers and studios
favor Epson for its range of quality inks, soft-
ware, and papers. Make sure you know what
print size you want to work with so you don't
buy a printer that prints too small or too large.

Developing a Workflow

The most challenging part of making the shift into
digital photography is that there seem to be so
many moving parts. You have to think about get-
ting the negatives scanned or moved from the digi-
tal camera to the computer. Do you shoot RAW*
or JPEG*? How do you get great scans, and how do
you tweak them in Photoshop? What inks and
paper make a great lasting print?
 You need to write down and follow a systematic
process that will take your captured images

through this digital maze. First, you need to choose one of two paths. Path one: shoot and develop film, convert it to digital by scanning, and then print it digitally; path two: shoot digitally and print digitally.

Shooting Traditional Film and Printing Digitally
- Capture the image on black-and-white negative film
- Process the film traditionally using chemicals
- Scan the negative to create a digital image
- Prepare image to print in imaging software with calibrated monitor:
 Adjust tonal levels
 Choose paper and printer profiles
- Print image and mount
- Log and backup final scans, both original and adjusted

Shooting and Printing Digitally
- Shoot image as color RAW image (RGB) or JPEG.
- Download image into computer file as RAW or JPEG.
- Calibrate monitor with system software or third-party colorimeter.
- Adjust and process image with imaging software and calibrated monitor.
- Convert image to black and white in Photoshop, using channel mixing or black-and-white plug-in to convert.
- Adjust image's curves and levels.
- Tweak image for final print.
- Choose paper, proof, and print.
- Log and backup digital image.

*RAW is the camera's proprietary uncompressed file of the image. *JPEG is a compressed state of the original image. Some cameras allow making both a JPEG and RAW image of the same image. Those who want to take their prints to their highest level will want to take their image as a RAW file into the imaging software.*

Shooting with Black-and-White Film

For those who have a tremendous investment in film cameras, or love to shoot black and white and process their own film, all is not lost. A number of photographers are shooting film and scanning the negative to get the image into digital form. In fact, some of my best digital prints are still coming from 4x5 film or 35mm negatives. With today's technology, you can even shoot in color negative or transparencies and convert to black and white with amazing results.

The major difference in negative size is obvious when you place a 35mm and 4x5 negative next to each other. But remember, bigger does not always mean better, it depends on your needs.

The biggest adjustment in shooting black-and-white film for digital scanning and printing over traditional darkroom printmaking is how one approaches the exposure. The well-known Zone system of exposure created by Ansel Adams had you taking spot meter readings off various parts of the region to be photographed and assigning them values from 0 to 10. Zone 0 is pure black and Zone 10 is pure white. The whole purpose was to visualize your final image as a print and then control shadow, highlight, and contrast in the negative so you could more easily make the print you want in the darkroom. If you used only the camera's light meter, it would read the average for maximum shadow and highlight detail, and more often than not fool you with a poorly exposed negative that

was difficult to print, hence the Zone system.

But since our goal is to take these black-and-white negatives into the digital arena, the approach can be different and, in some cases, easier. Knowledge of the Zone approach may be useful, but is only marginally related to the digital path we're taking. When scanning your negatives, you want to expose a full-toned negative in the camera so you have enough readable tone on the negative to make a high quality scan. You will then make all your contrast and level adjustments in Photoshop.

What do I mean by full-toned negative? To make a good scan, you really don't want a negative with highlights so densely exposed they are difficult for the scanner to project light through. Scanning negatives with blocked-up highlights is difficult. In the digital world, it's much easier to rescue underexposed images than it is to find any detail in an overexposed negative. There has to be something there for the scanner to record before you can start shifting tonal values around.

You really want a full range of tones to work with while you're shaping the tones in the scanner software. Never wait to fix it in Photoshop. From the negative down through the final print, your work will stand miles above others if you value each step of the process. Waiting to make major adjustments of a poorly exposed negative in the scanner or, worse yet, in the computer will give inferior results. Master the technical before you become the artist.

Shooting in Color Film

You also can shoot your film in color transparency or color negative, have it processed in a lab, and then scan it and convert it to black and white using the scanning procedure described later in this chapter. There are advantages in doing this if you're unsure about whether you want a particular scene in black and white or color. There are certain steps

you'll need to do in your imaging software to make this work, but the results can be very effective. The disadvantage is that you are always riding the fence as to whether you're a color or black-and-white shooter. If you're a weekend photographer that's fine, but if you're defining a style and look to your black-and-white work, working strictly in black and white puts you into a frame of mind that will lead to more successful black-and-white images.

Processing the Black-and-White Film

Agfa, Fujifilm, Ilford, and Kodak all make excellent black-and-white film. All have detailed information on their Web sites to assist you in making choices about which film to use. I have had great success with Kodak's T-Max at 100 and 400 ASA (ISO) in 35mm and 4x5. I suggest you find a film that works for you and stick with it. Really get to know what it does and how it reacts to certain light. There are many books, magazines, and Web-based articles that discuss films and processing, but the process is fairly straightforward.

Film size will affect your choices as to whether you'll use reels and stainless steel tanks to process your film or make a simple darkroom to process 4x5 sheet film. If you're sticking to 35mm or 6x6cm (120 or 200 film), you can get by with a changing bag to load the film onto reels in the dark and then once they're in the tank and the cover is on, you can complete the whole process in daylight. Here are the steps using Kodak's processing chemical D-76, my standard. The www.kodak.com Web site has full specifications:

1. Load the film in the tank in total darkness or in changing bag.
2. Prepare D-76 for developing. If D-76 is mixed 1:1 (one part D-76 to one part water) you will get added sharpness, but a slight increase in grain.

3. Using a darkroom thermometer, keep temperature of D-76 at 68 degrees. Avoid any temperature above 75 degrees. At 68 degrees, the correct time for T-Max 100 film is 9 $^{1/2}$ minutes with D-76 diluted 1:1.

4. Pour D-76 in tank and be sure solution fills to cover all the reels. Cover with lid and start timer. You can use correct-temperature water as a presoak for more even development and to help keep bubbles from attaching to the film.

5. Agitate the film every 30 seconds by inverting slowly. Tap lightly on counter top (from an inch above counter) to free any air bubbles that may have formed on the film which could create undeveloped spots on your negatives.

6. After the time has expired, drain the D-76.

7. Add stop bath and maintain all chemical temperatures within a few degrees. Stop bath quickly stops the processing. It is color-dyed yellow, so as it depletes, it will turn purplish.

8. Empty stop bath back into its container and pour in correct-temperature fixer.

9. Begin timer again, and at one minute remove lid from tank and check film.

10. When the film clears completely, make a note of elapsed time. Fix the film that much longer or follow Kodak's fixer times.

11. Rinse in clear temperature-controlled water for 30 seconds.

12. Immerse film in Kodak's Hypo Clearing Agent for two minutes, wash for five minutes.

13. Soak film in Photo-Flo for 30 seconds to help the film dry without water spots.

14. Some people also squeegee film to prevent excess water, but be careful not to scratch film.

15. Hang film up to dry in a dustless area.

16. When the emulsion side of film is concave, the film is dry. Anytime before that you can easily scratch the film.

FOLLOWING PAGES: Street photography shot in black and white yields a mood and quality where color can often distract. This scene from a New Orleans Mardi Gras event seems to be made for black and white.

Shooting with Chromogenic Films

Wouldn't it be great if you could shoot a black-and-white film and simply take it down to the color one-hour photo kiosk? Well, you can. About 20 years ago, Ilford introduced the first chromogenic film, XP-1. This film was specifically

Negatives from processed chromogenic film appear to be like color negatives, but yield a neutral toned black-and-white image when printed.

designed for those who photographed in black and white and didn't want to bother with darkroom processing, allowing them to develop their rolls with the standard color-negative film process offered at the local one-hour photo shop. This film produces a "neutral" dye image as opposed to the conventional silver-grain image on black-and-white films. The dye images can be printed using standard black-and-white or color papers. Ilford has a new and improved version of this film named, affectionately, XP-2.

Seeing the growing popularity of Ilford's black-and-white chromogenic film, Kodak came out with their own version, called T400CN. It has now been

replaced with their BW400CN ISO 400 film. These films by Kodak and Ilford come in 35mm and 120/220 sizes that can be conveniently developed at your local photo store. Agfaphoto makes a black-and-white reversal film called Scala, which has to be processed in one of their designated labs.

Since we are going to scan and print digitally, you might find the dye clouds of chromogenic films give better scans. Traditional film's grain can be intensified by the scanning process. The other advantage, besides the convenience of local processing of these chromogenic films, is having small record prints made, which solves some of the proofing issues.

Issues to consider in choosing film and processing:

- Fast films such as ASA 400 films will be grainier then ASA 100 films.
- Chromogenic films can be processed at the local one-hour photoshop.
- The larger the negative (4x5 or 2 $^{1/4}$), the better the detail, and large prints will have less grain than 35mm.
- 35mm and 2 $^{1/4}$ -inch negatives can more easily be processed in lightproof tanks after loading the reels in a changing bag or darkroom.
- 4x5 or larger films require tray or film-holder processing in the darkroom and require extra care in handling and drying.
- Larger films require more expensive film scanners to accommodate their size.
- All black-and-white film processing needs to follow the manufacturer's temperature, developing times, and agitation requirements.
- Poor processing and agitation technique yield uneven negative densities and streaks, resulting in negatives that are difficult to scan and print. Agitate regularly, smoothly, and gently.
- The last chemical processing step of fixing and

washing thoroughly is extremely important for archival purposes.

• Dry carefully, cut and sleeve in archival negative sheets, proof, and log in subject.

The Unromantic Histogram

A digital camera allows you to work directly with the digital image, without the difficulty of going from film to scanner to computer. It gives the photographer a high level of control over the image before it is downloaded into image-management software. The histogram, which gives the photographer a visual reference in the camera, is probably the least understood and most feared imaging tool. Most digital cameras, and certainly the high-end ones, have the ability to show the histogram under or superimposed over a thumbnail of the image just taken. This tool is also the reason most of us don't use a light meter any more.

When you see a professional photographer looking at the back of his or her digital camera after every few photos, they're most likely looking at the histogram. The histogram shows the distribution of the photograph's tones over a 4-stop dynamic range. Most digital cameras can handle a 5-stop dynamic range. You simply need to make sure your exposure from black to white stays within these limits. Seeing the graph all bunched up to the farthest right shows the image is overexposed and that many image pixels will not have any information. Overexposure in digital is like overexposure with transparency color film; there is usually no way to save the image because there is simply no information or detail.

Even for converting a color image to black and white, you want the brightness values to be within the histogram's high and low limits. At times you might want to experiment with or break those rules, if your image were high-key, for example.

Notice that the camera has a grid of lines over

the histogram. The lines represent the tone sectors from dark, medium dark, neutral or mid-tone, three-quarter tone, and white.

In real-world situations you will almost never find the perfect exposure, but the histogram will aid you in making settings that let the exposure fall within the approximate 5-stop limit that most digital chips can capture. Ideally, you won't take the image over the white limits at all.

Processing the Digital Image

When you set up your DSLR (digital single-lens reflex) to take photographs, you should capture the image in the camera's native resolution (RAW). You can certainly capture the image as a JPEG, but if your goal is to make good gallery-size black-and-white prints, the RAW format holds all the original color data coming off the camera's imaging chip and will convert best to black and white. Some cameras will process two files, one RAW, the other in JPEG.

But the most important file is the one in RAW format, which holds color and exposure data that can be more finely tuned in imaging software such as Photoshop CS or C1 Pro by Phase One.

The first step is to take the photos that reside on your camera's compact flash-data card and download them on to your computer's hard drive to process in your imaging software. This folder of RAW images should also be backed up on CD or DVD in its native state, in case you should ever want to go back and work on an image from the beginning. You do not want to have all your original RAW files sitting on a hard drive that crashes or a data card you erase.

Digital cameras contain a wealth of exposure information that also includes thumbnails and a histogram that shows exposure level. Keeping within the limits, especially the highlights, ensures printable image detail.

Now let's process one of your selected RAW files. These will be RGB color images, and we will convert these later to black and white in the chapter on digital editing.

You should be able to see your downloaded RAW files in Adobe Photoshop's browser window. (Window Photoshop's menu bar, Window>File Browser.)

1. Make your color space Adobe RGB (1998)
2. 16-bits/Channel (you can use 8-bit, but 16-bit is better.
3. Resolution should be 300 dpi at native negative pixel size
4. Adjust white balance either using presets (cloudy, tungsten, daylight) or, if your monitor is calibrated, tweak the color temperature and tint to your tastes.
5. Tweak the exposure, shadows, brightness, contrast, and saturation so the histogram is filled out across the window or tonal levels are where you want them. Unless you want some unusual effects, do not extend these tones past the end points. You will be able to do further adjustments on the image later, after it has been processed.
6. I would add only a slight amount of sharpening (<50), luminance smoothing (<20) and color noise reduction (<25). You can blow up your image to 200 percent or more to make sure you're not adding too much or too little control here. Too much sharpening will add highlight edginess. You don't want the image to feel unreal or jazzed up.
7. Use the lens feature and enlarge to 300 percent or more, then focus on some vertical element or edge in your photograph and look for green or red smearing along the edges. Make your adjustments until these colors disappear. This chromatic aberration is caused by light passing through the lens

and not focusing the different wavelengths at the same exact focal plane. Wide-angle lenses suffer the most from this.

8. Finally, you can adjust various colors or regions in your image by the various sliders in the "calibrate tab." This requires a really soft touch to shift the colors in your image.

9. Once you process this image you will reopen it in Photoshop and follow my "Converting Color to Black and White" instructions.

Keeping Organized

It is a good idea to develop a system to keep RAW, processed, and images converted to black and white in different folders or name them so you can easily differentiate between them. The file name should contain some of the file number the image was originally assigned by the camera.

Later, when you make a print, you can pencil in the black-and-white file name. But you could always search for 0889 and find the original or the color or black-and-white file. Listing this number

In this digital age, images can get lost or erased from hard drives or flash cards. Keep proofs, write down file names on the proofs, and keep a database to stay organized. Most important, backup RAW files to DVD or CD-ROM or another hard drive.

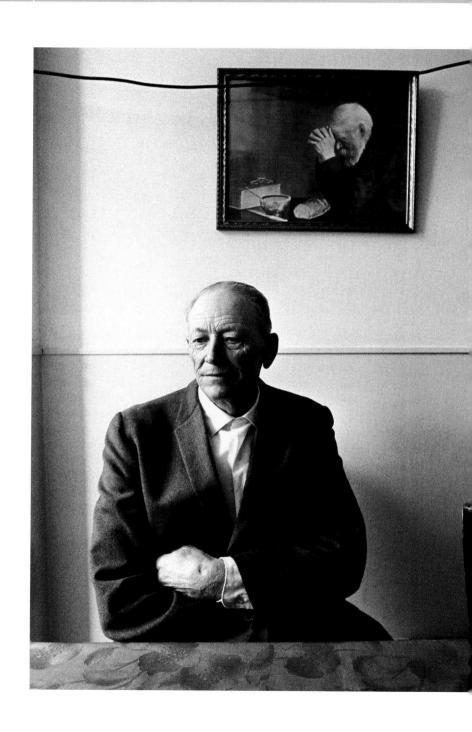

in a database would make your life even easier when you go looking for it later. Make sure your database includes the CD or DVD name.

At this point you have taken your film or digital image through a chemical or digital process that now prepares you to make a black-and-white print from an inkjet printer. This chapter has been rather technical, but don't let it divert you from your vision. And don't worry, some of the greatest photographers who have worked in both color and black and white have learned through trial and error and sheer tenacity. Eventually you will make photographs that you will enjoy for years to come.

I am still drawn to the moment and lighting of this image I took at a small-town restaurant. This is what black-and-white street photography is all about.

Proofing and Logging-in Film

One of the challenges in shooting lots of film for digital scanning and printing is having all these negatives and making an educated decision as to which ones you want to scan and print. It takes a learned eye to see the pearls. Creating proofs from your negatives is one way to find images you like and keep your work organized.

If you are shooting digitally, it's somewhat easier to create a visual proof using Photoshop's advanced image browser. From within the program, Photoshop allows you to look at your folders of images in proof-sheet form. You can also name, add metadata (embedded information) to each image, and tag images you want to print. And best of all, these organized images can be printed on standard letter-size paper on an inexpensive inkjet printer.

But when you've just processed 50 4x5 sheet films, or 5 rolls of 35mm in negatives, it's hard for even seasoned professionals to get a feel for what they've got. You really do not want to scan in every frame to find the one you want to print. If you have a darkroom, you can make contact sheets in the traditional darkroom way by contact printing the negatives on an 8x10 sheet of silver-gelatin paper. Before you develop the proof, pencil on the back

the same number you assigned the negative sleeve.

If you've decided to use the chromogenic black-and-white films by Ilford or Kodak, you can have small prints made off your rolls. This certainly requires the least work and is a great way to create a small album of your work before you print the masters. But for most of us shooting black and white digitally, there is no darkroom to organize all the black-and-white negatives. There is a solution, though.

You could use an inexpensive flat-bed scanner such as the HP Scanjet 4600, whose scanning elements are contained in a removable lid and can be moved onto books or other items such as your sleeved negatives. Your negatives must be on a light box or some other lighted surface that will shine enough light through your negatives so the scanner can record them. You then convert the scan to a positive image. You don't have to necessarily print these digital proofs as long as the file name is numbered the same on the negative sleeve. It all sounds a bit tiresome, and like any front-end office work, it is. But years later when you are looking for one particular frame, you'll thank yourself for doing the extra work. No one said that going digital really makes the work any easier.

Remember, any flatbed scanner that has a light on the lid to scan transparencies laid down on the glass should be able to scan a whole sheet of negatives. You can also lay a portable lightbox on top of the sleeves as they lie on the scanner glass. This all takes a bit of experimentation to get it right.

Creating a Database

In the digital realm, keeping a record of your images is imperative. I use a simple database, Microsoft Works, to create a simple keyword-record database of my scanned and printed images. I include main key words from important negatives in each sleeve, ones I know I will be able

Tip

Whether you calibrate using Photoshop's Adobe Gamma utility or the Macintosh Display calibrator, you should always use the same subdued lighting. If you calibrate in a sunshine-filled room and then later work in subdued light you will have inconsistent results.

to remember down the road. If the image was taken, say, from a boat in a winter storm on the Chesapeake, you select subject keywords such as, Chesapeake, boat, winter, and storm. Then enter the negative sleeve number where it is filed. If any of these are scanned and backed up, create a serial number for each CD, such as today's date, write it on the CD or DVD, and make a note of it on the database. Any proofs or prints should have this number penciled in on a bottom corner. Always use pencil on your prints to avoid streaking, bleed-through, or fade-through to other prints. When you pick up a print, this small number can point you back to your digital files or DVD backups.

I want to emphasize the need to take time on the front end to do this proofing and data entry. Without this logging in of data, especially in the digital workflow, you will be completely over-whelmed later on.

Calibrating Your Monitor

You need consistency from negative to negative, and this begins with a calibrated monitor. It's amazing how monitors can be all over the place when it comes to contrast and brightness control. You have to assume the monitor's settings and values are not completely true, and your goal is to adjust them to an industry standard. You need to be able to see the subtle levels of gray from light to dark (the human eye can discern a hundred steps of lightness). Otherwise the adjustments to your negatives are based on visual information that is off to begin with. A calibrated monitor will ensure that the important changes you made on the screen will be reflected in your final prints. And if you send a digital file to an art director, you can be almost certain that what you see on your system will be the same as what the art director sees.

LCD screens are flat, liquid-crystal display monitors only inches thick, while the older cathode ray

FOLLOWING PAGES: Calibrating your monitor helps to identify and adjust for subtle tonal variations in digital black-and-white images. Improper monitor calibration would cause the image on the following page to appear muddy and indistinct. Properly calibrated, the monitor will represent the subtle interplay of highlight and shadow and facilitate adjustment of contrast.

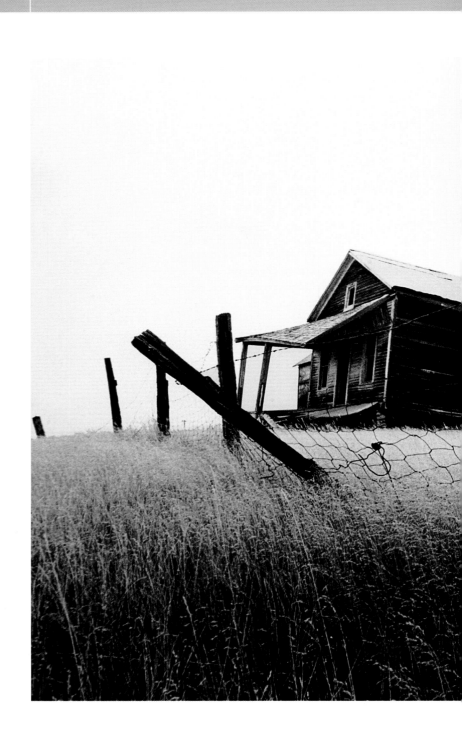

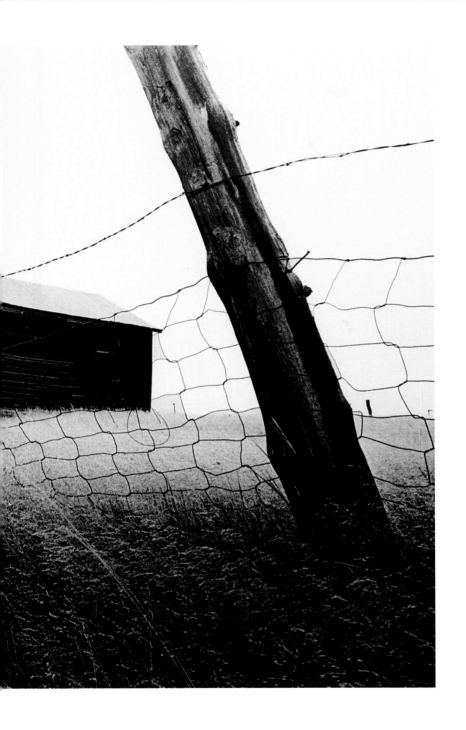

CRT monitors can take up a desktop. Ideally you need a monitor that allows adjustments on brightness, contrast, gamma settings, and more. But don't throw away that older technology. Most good CRT monitors still have a wider tonal range then LCD monitors and make for a better imaging screen. In recent models though, manufacturers such as LaCie, Sony, and Apple have developed LCD monitors that can rival the contrast and color range of CRTs. (I work with two screens, a LaCie Electron 22 blue III and an Apple 23-inch display monitor.) By creating a 21-step grayscale, you can easily compare the tonal ranges of your monitors at their present settings.

There are two ways to go about calibrating your monitor for color and black and white. If you have

It's important to calibrate your monitor to a standard grayscale so adjustments to your black-and-white images will provide consistent results when printing or sharing photos.

| 100% | 90 | 80 | 70 | 60 | 50 | 40 | 30 | 20 | 10 | 5 | 0% |

Bad monitor settings show little separation of tone from 75% and higher

| 100% | 90 | 80 | 70 | 60 | 50 | 40 | 30 | 20 | 10 | 5 | 0% |

Good monitor settings show separation of tone from 75% and higher

Software monitor calibration can be achieved on a PC by using Adobe Gamma, which can be found in the Control panel after Photoshop is installed. You also need a monitor that allows you to adjust contrast and brightness manually.

a Macintosh, you click on the "displays" icon in System Preferences and use their calibration procedure for your monitor.

If you're working on a PC, start Photoshop and open the help window from the program's menu bar. A PDF manual will open up, and you go to the index or search for "Producing Consistent Color (Photoshop)." That heading will lead you to a series of informative help steps that will show you how to calibrate your monitor using Adobe Gamma Utility.

Finally, you can go back to Photoshop and, in Color Settings, you can make your setup using a dialog box similar to the one pictured above (PC users will want to set Gray>Gray Gamma 2.2).

By adjusting your monitor's settings and changing the Color Settings in Photoshop, you have leveled the playing field so that your

monitor's contrast and levels will show a full range of tones and help you adjust your negatives, scans, and digital images against this norm, providing a baseline from which you can make beautiful prints. Trust me, few of us really understand all of this at any significant level. I didn't really understand all the chemistry behind the processing during the darkroom days, but that didn't stop me from understanding enough to get what I wanted.

Creating a 21-Step Wedge in Photoshop

- Create a new, blank file under File>New. Make sure the Mode is set to Grayscale.
- Size it to print at 7x5, 16 bit, and 300 dpi. You can crop this later.
- Create 100 percent black in the foreground and 100 percent white in the background of the color palette.
- Select the gradient tool. Set the linear gradient to retain the setting Foreground to Background, then choose Opacity 100 percent, Normal mode.
- Drag the cursor from one end of the frame to the other.
- Using a rectangular marquee tool with no feathering, place a rectangle from end to end through half of the image.
- Now you will create 21 steps on that half. Choose Image>Adjust>Posterize. Set 21 as a value, click okay. This will create a perfect step wedge from 0 percent to 100 percent in 5 percent increments. You can create a step wedge in 10 percent increments; you have to enter a value of 11. Check the value of each step using the info tool, Window>Show Info.
- You can finish this off by making labels with Photoshop's type tool. Keep this image on your desktop to call it up when you need it.

Prices have come down significantly on monitor calibrators such as the Eye-One by GretagMacbeth. Calibration eliminates any guessing as to what the monitor settings should be.

Hardware Calibrator

Another option, the one I recommend, is to invest in a monitor-display calibrator, such as GretagMacbeth's Eye-One Display, ColorVision Spyder, Digital Light & Color's Mechanic, or Monaco Optix XR. These compact colorimeters and their software allow you to achieve consistent, predictable color on both LCD and CRT monitors. There is no guessing on your part as to the right contrast and white-point settings.

To calibrate your monitor, you simply attach the colorimeter to the front of the screen (either hang on the LCD or attach with suction cups to the CRT) and follow the software steps through the monitor calibration. When the calibration is finished, you name the file and it becomes your personal default

profile for that monitor when it starts up. Yes, this is another expense, but the cost of the calibrators has come down dramatically and would be a wise investment. Taking time to calibrate your system on a regular basis will help create a consistent platform from which you will print.

These companies also make dual calibrators that work on monitors and printed output for the ultimate in calibrating your digital work to your monitor and printer.

Film Scanners

Outside of your camera gear and computer, the film scanner is the next major investment needed to build a digital darkroom.

You can avoid the upfront cost of buying a scanner by having an imaging-service center do scans for you. The prices can range from $20 to $150 for

The range of options for scanning negative film is impressive. You can spend $100 for a lower-quality flatbed all the way up to $10,000 or more for a Imacon virtual drum scanner. Reasonably priced midrange scanners such as the Nikon Coolscan series can offer high quality for their price.

each scan, depending on their size. But be careful and watch for sharpness and quality of the scan, since many bureaus offering low-cost scans are tempted to run their work through as fast as they can to justify their low prices. If you're serious about black-and-white photography, I recommend buying the scanner. The savings will be significant over the years and this is where you really learn how to photograph digitally.

Nikon Coolscan 9000 ED (Nikon) Nikon Coolscan V ED (Nikon)

For beginning photographers on a tight budget, the costs to build a digital darkroom can seem monumental. E-bay and camera stores have good prices on used photo and computer equipment, which can substantially reduce your costs. But you need to be aware that incompatibilities between cameras and computer systems may exist on used gear.

The serious amateur or professional will need to invest in a good scanner that can give sharp edge-to-edge scans, be able to read detail in the shadows, and have decent software to support it. Getting the best scan of your negative is worth the investment. A number of companies make good film scanners for 35mm slides and negatives, 120mm, 220mm, 4x5, and larger. You can spend $500 or $20,000 for a high-quality dedicated desktop scanner. If you plan on scanning both prints and film, then a flatbed scanner might be the choice. Some excellent flatbed scanners have transparency and negative strip adapters. But remember, if quality is your goal, avoid scanning prints and go straight to the original negative. Buy the highest-rated scanner and printer you can afford. It will be evident in the quality of your work.

If your intention is to make 16-x20-inch prints and larger from your film scans, I suggest a scanner

Imacon Flextight 848

to your tones, colors, and file size in the scanning portion, you won't be left with half a box of data that will deliver a poor quality photograph.

So the Steps Are

- Place your clean negative or negative strip into the scanner.
- Pre-scan your negative as black and white.
- Use the crop tool to set the scanning area.
- Set the dimensions, resolution, and bit depth of your scan as high as practical.
- Adjust the curve in the histogram for good separation of highlights and shadows.
- An alternative is to scan your negatives as color positives, invert them in Photoshop and then convert to grayscale. You might achieve a better use of the scanner's dynamic range with better shadow detail and less chance of blowing out the highlights. Some reduction in grain enhancement can be achieved.

The first step in scanning is to clean off your negative. It seems like an obvious step, but many people overlook this and waste time later in Photoshop spotting out all the dust. Use compressed air or a camel-hair brush. Hold the can upright and squeeze off a couple of test blasts to clear any propellant from the tube. Use a light touch on the trigger. Quick, delicate blasts will usually do the trick. If you use a brush, don't handle the brush end because oil from your hands will eventually make the brush useless.

Follow the scanner's instructions for inserting the negative film into the scanner or flatbed. Some scanners require the purchase of a negative holder. Most important, you want the negative to be held as flat as possible, so watch out for bends or crimps as you load it. This is a delicate process so be careful not to scratch or place fingerprints on the emulsion side. White cotton negative gloves are a help.

Next, the scanner software will allow you to pre-

Tip

If your intention is to make 16x20-inch prints or larger from your film scans, you need a scanner that can give you a high-resolution scan of at least 4,000 dpi at the 35mm film's actual dimensions. Some go higher, which is helpful for extracting the maximum information from your fine-grained negatives. Also look for a scanner with a high dynamic range of 4.2 or higher.

view the image before you scan. This is where the critical tonal corrections and cropping should be done. Place the crop marks just outside the image area. After the scan, you can crop unwanted areas of the image in Photoshop. Make sure your scanner settings are set to grayscale and either 8-bit or 16-bit scans; 8-bit scans can give you 256 shades of gray, while 16-bit scans can give you 65,536 shades of gray. Later, as you make contrast corrections in Photoshop, you will lose less tonal information as you make your adjustments. If you look at the histogram in Photoshop after making corrections in 8-bit and then compare it to changes made in 16-bit, you will see the characteristic white lines of missing tonal information in 8-bit. Some people might argue that your printer will never deliver these variations. But who can argue against master scans with as much information available saved for

It is important to adjust your image values before the scan, rather than after. Use the all-important histogram to set your desired contrast and lightness values.

all future work and adjustments? Scan your most important work in 16-bit if you can.

The two scanning tools used in preview mode that are critical to a good grayscale scan are the histogram and the graduation curve. The histogram sets the upper and lower limits of the image values, and the graduation curve shows the relationship and levels of the actual tones in the image. Most software uses black, gray, and white diamond symbols at the base of the histogram to represent the tonal limits of the darkest (0 equals pure black with no details) through to the lightest (255 equals pure white with no details) image values. The goal here is to move the black-and-white inputs to the outer limits of the graphed image.

A black-and-white photograph can be more than just a record shot of a family. My dad made this photograph of my sister and me in 1948.

On the pre-scan of the tree (see photo on page 113), I reduced the dark end of the histogram input of blacks seven points and left the light end where it was, since most of this image has a bright washed-out sky. The mid-tone diamond always stays in the relative halfway position between the two extremes. Next, I changed the curve downward in the middle tones, which darkened the ground a slight amount, and I raised the highlights just a bit so they weren't too gray. To summarize, before I scanned, I took the preview histogram and lowered the dark levels, then darkened the middle tones using the curve tool and lightened the sky just a notch. I will scan this in 16-bit at 35mm size at 4,000 dpi. The file will be about 110 megabytes. Later, in Photoshop I can resize this and convert to 8-bit after I've made all my additional corrections.

This might sound complicated to the uninitiated, but I suggest you jump right in and learn to scan by trial and error. Learn what you can from the manuals, but just make photographs and dive into the process. You can't break anything by playing with the software and trying some extreme moves just to see the results.

BRIAN PETERSON
Documenting People & Place

Brian Peterson

BRIAN PETERSON has worked as a staff photographer at the *Star Tribune* newspaper in Minneapolis, Minnesota, for 18 years and has been named Minnesota Press Photographer of the Year nine times. His six-year documentary of a rural Minnesota family's struggle with AIDS was honored with a Robert F. Kennedy Award for Photojournalism and the Canon Photo Essay Award from the National Press Photographers Association. Peterson also initiated, photographed, and produced a year-long feature called "Voices for the Land," which looked at issues surrounding land use and urban sprawl. The series was published in book form by the Minnesota Historical Society in 2003 and won three Minnesota Book Awards. He calls it one of the most satisfying projects of his career.

"I purchased a camera with high school graduation money. I always loved art, but I started noticing photographs that had a certain depth of field. I remember a certain special photograph that looked better than any family snapshot I had ever seen, and I began to realize what you could do with a camera besides family photos.

"I was going to major in biology in college and, ultimately, live in the woods. I didn't really

"This is one of the hardest pictures I've ever had to take despite having worked with this rural farm family for six years documenting their struggles with the deadly AIDS virus. Eric had brought his mother, Nancy, a tulip

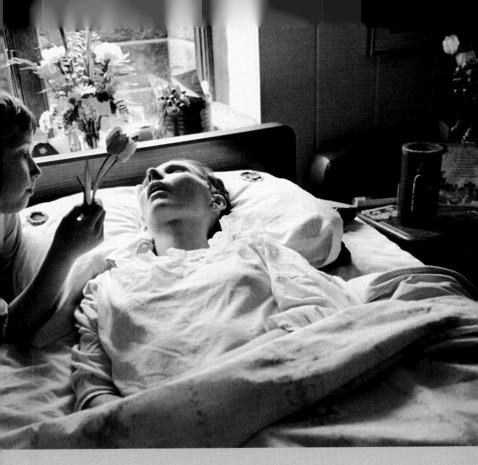

from the garden
shortly before she suc-
cumbed. Even though
we had color avail-
able to us, there was
never any doubt that
this story was stronger
in black and white."

think about being a photographer until I was
well into my first year in college. Then I started
looking around at different schools for a photo
course. Eventually, I ended up at Bemidji State,
where Cheryl Younger was teaching. I started
taking photojournalism classes from her, even
though she was a fine-art photographer.

"Early on I was getting positive feedback. I
had a knack for composition and lighting and I
was watching other photographers to see how
they told stories. I started working on the student
newspaper to get as much experience as I could. I
guess early on I was more of an illustrator, trying
to make visual points for the writer's story, rather
than expressing my own vision.

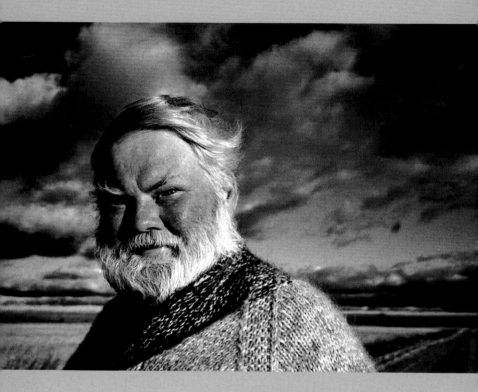

"After school I applied to many newspapers, and one small Minnesota paper finally took a bite. They said they were either going to hire me if I could shoot a daily front-page picture or keep the AP wire machine. So they hired me and got rid of the AP photo machine.

"Black and white was my first love, but I was increasingly working for papers that were using color. I was making photographs where the color of the subject matter seemed more important than the content. I really wanted to work for the Minneapolis *Star Tribune*, which had a rich history of strong photographers telling strong visual stories. And I finally succeeded. I had a short taste of working in black and white again until they, too, shifted to color negative.

"With all this shifting from black and white to color in my career, I never forgot how the great masters communicated. I studied the work of photographers like Eugene Smith, Robert Frank, Cartier-Bresson, Eugene Richards, Elliot Erwitt, and others. Most of it was in black and white and reflected a sophisticated way of seeing. I could see my color work didn't communicate the same way. I knew that the newspaper was now moving completely to color negative and I was scared that my chance to communicate in black and white would be lost forever.

"But attitudes toward the use of black and white began to shift. There was a tragic story about a farm family in Minnesota where both the father and mother, along with their daughter, were infected with AIDS. They decided to allow me into their lives to document the difficult road they faced over the coming years. It seemed appropriate to shoot this story in black and white. Back then we'd make black-and-white proofs and make small thermal prints. I shot about 18,000 frames and made about 400 prints from a standard 35mm enlarger. That was one of the last projects where I used an enlarger because we began to scan our negatives digitally. The story had a very sad ending.

"I did a series called 'Voices for the Land,' and I interviewed and photographed people who were writing their impressions about their favorite place. It was amazing how ordinary people could communicate what meant the most to them about a place. I didn't want this to be a pretty book, a sunset book. I wanted it to be a heartfelt book. I knew I'd have only a short time with these people, so I wouldn't have time to wait for the color to be right. I was more interested in texture and moment and more of a feel

"This story was part of larger newspaper project and book called *Voices for the Land.* It was to be a portrait of writer Bill Holm. We talked for an hour at the kitchen table before I got him outside in the morning light where I was able to accentuate the rich texture of his face."

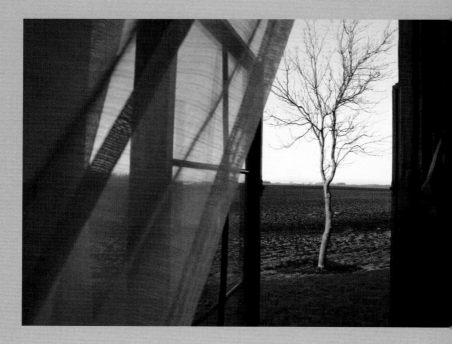

"I was working on a project about small town life and was staying at the Sheep Shedde Inn in Olivia, Minnesota. All the rooms faced the expansive cornfield, and a tree was planted outside every window. With this image you can almost smell the earth and feel the spring breeze."

of a place than the look of the place. Shooting in black and white seemed to add to their essays. The whole project, printed in black and white, is one of the most satisfying of my career.

"I was amazed how the readers started to connect to these black-and-white stories. I speak to groups about this project, and people come up to me and say how much they appreciate seeing them in black and white. They could see the reasoning behind it. There is so much color that when we do run a story in black and white, it feels more special. I think there will be a great resurgence of black-and-white photography.

"I started doing a series converting color negative to black and white. Then I started shooting the early Canon D30 and I actually felt that some of the digital images were better. There was a quality and lack of grain that showed me what digital would become.

"This digital shift is a lot like the shift from 4x5 Speed Graphic to 35mm. Many photographers never made the transition. For us the first digital cameras were awful. We got terrible skin tones and a horrible color range. But slowly the digital chip improved. The image quality for portraits and landscapes finally moved me from film to digital. It handled shadow detail in ways that film could not. This was the turning point for me. I was seeing things in the digital image that I would never see in film.

"Now my big project is 'Witness,' an occasional series that explores the ordinary and the extraordinary; it's an effort to capture the rights of passage, rituals, and traditions of the changing face of Minnesota life. It made sense to do this in black and white, so that it will not look like every other story. And I cannot think of one of these profiles that would look better in color."

Brian Peterson Tips

■ Working in the darkroom can't hurt. Everything that I do in the digital darkroom, I learned in the wet lab.

■ Don't burden yourself with equipment. Too much equipment will build a wall between you and your subject. Keep it simple, one or two camera bodies and two or three lenses.

■ Shooting in black and white allows you to think purely about your subject. Focus on emotion, form, light, and composition and ignore the distractions of color. Use it to your advantage.

■ With the new digital technology, you have a permanent Polaroid built into your camera. Use your LCD screen to experiment with different exposures and lighting techniques.

■ Always ask yourself, "What am I trying to communicate?" And then try and make pictures that speak to what you are trying to say.

■ People make most pictures more interesting; even breathtaking landscapes often benefit from including humanity.

■ Pick a system that works. If you get good results or a print that is satisfying, stick with it.

Converting Color to Black and White

FOR YEARS I HAVE CARRIED both black-and-white and color-transparency film and struggled with which to use. Later, when I began to work more in large-format black and white, I carried red and yellow filters along to darken the sky and accentuate the clouds. Now, with all the digital controls available, I can shoot all color film and convert my images later to black and white.

Those new to Photoshop may have found it relatively easy to convert color scans or digital images into black and white by just changing the image mode to grayscale. This is Photoshop's vernacular for black-and-white imaging. But this process most often will not produce the best possible result. An image that is successful in color may be dull as a black-and-white photograph because there is very little difference between gray tones. Photoshop's "convert to grayscale" chooses equally from all three RGB color channels and guarantees dullness.

There are more sophisticated and successful approaches using Photoshop's channel mixer controls or a conversion plug-in such as nik's Color Efex Pro or The Imaging Factory's B&W Pro. These controls or plug-ins help you convert to a grayscale photograph as if you were applying red, blue, or green filters in various combinations. This allows you to shift traditional tonal effects such as the lightening of foliage or darkening of sky as if you had shot them through filters. Navigate the path through the Photoshop windows as follows: Image>Adjustments>Channel Mixer.

Use Color Channels to Change to Black and White

Rather than buy a color- to-black-and-white Photoshop plug-in converter, you can easily achieve the same results using the color channels in Photoshop's Channel Mixer. This is how it works. Create a new adjustment layer over your image with Channel Mixer (Layer>Adjustment Layer>Channel Mixer). When the Channel Mixer window appears, check the monochrome box at the bottom, which will convert your image to mono-

Digital editing requires a certain amount of computer and imaging equipment, not unlike the investment required to construct a quality darkroom. Still, the costs are higher for today's electronics than for the old darkroom.

Tip

When you see the connection of words such as Image>Adjustments>Channel Mixer, this is the path you should follow in navigating through the Photoshop windows.

chrome with the red value at 100 percent. The process now is to adjust the red, green, and blue sliders to achieve the tones you want. You must make sure the percentages are equal to 100, e.g., red at 35, green at 45, and blue at 20. Using Channel Mixer gives you great control over the color to monochrome tones, since using each slider individually is like using a red filter or a blue filter on your lens when shooting black-and-white film. Try placing just the blue at 100 or the green at 100 to see what you get. At this point, you can convert this file as a grayscale using the channel adjustments with the black-and-white tonality you have shaped. Once you get the image tones you want, save this file under a new name, being careful not to write over the original color scan. You might want to go back to it at some later point.

Now you are ready to see how a converted color image prints as black and white.

9.tif 1

10.tif 1

11.tif 1

12.tif 1

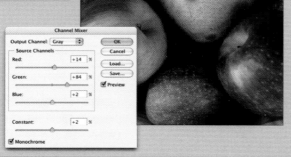

13.tif 1

Plate 9. All the red, green, and blue channels are turned on showing the normal RGB image. Plate 10. With only the red channel on, the lightening effect of a red filter is evident. Plate 11. With only the green channel turned on, a more realistic rendition is achieved. Plate 12. The blue channel alone is too dark. Plate 13. Create an adjustment layer>Channel Mixer and by selecting monochrome at the bottom, arrange sliders to your taste but not to exceed a total value of 100.

The best way to achieve a balance between the individual colors in converting to black and white, is to use the Image>Adjustments>Channel Mixer. Here's where it's up to you to decide how you want to mix the various channels to get the look you're after. Now you can convert to Image>Grayscale and save the file under a new file name

Your calibrated monitor, a printer with a RIP using a profile for the paper and printer, should bring the final print very close to what you have on the screen.

As your expertise in Photoshop grows, there are other methods and combinations of conversions, such as using the lightness channel after you have converted the RGB scan to LAB color in Photoshop's Mode window. By using layers and making selections of parts of an image and copying between different selections of these layers, you can exert tremendous control over the final image. For example, you can select around one of the apples

and paste it into another layer. Then in that layer you can change the contrast and a host of other Photoshop controls. There are many books that can lead you through the many complex Photoshop controls. Do not be discouraged if you don't understand all of this to begin with. It will come with time, as you study the manual and do online research. I've been working in Photoshop for 12 years and I'm still learning something every day.

This image of Swallowtail Lighthouse on Grand Manan Island, New Brunswick, was a digital image originally shot in color. I found the black-and-white conversion more pleasing and dramatic.

Adjusting the Digital Image

Let's take a 4x5 negative I've scanned and follow how I used a few simple tools to ready an image for printing. First, as we've discussed, I wanted a scan that wasn't too extreme in its contrast and brightness settings. I also scanned it in 16-bit so when I do make my alterations in Photoshop, there would not be large gaps in the tonal range. You can always call up an image's histogram and see how many

missing tones there are by the number of white slices appearing in the black regions that represent the spread of tonal information. Play around with this and see how making big changes in contrast and brightness, especially in 8-bit, will result in big tonal gaps. In Photoshop you can find the histogram by going to Window>Histogram.

The first step I take is to select curves and work on the various regions of tone that I feel are needed. This is where a darkroom pro has an advantage because this process is almost the same as adjusting the contrast and burning and dodging.

If you look at the curve, you'll see a black-to-white bar on both the left and bottom sides of the graph. There are also lines, which represent the quarter tones from black to gray to white. Along this line you can select various tones of your photograph and move them up and down slightly to shift values from their original ones. You can click along the line to anchor a spot and then use the arrow keys to move around. You can also put numbers into the input and output boxes.

But the goal here is to start creating the tonal texture you are looking for. In the image of Kachemak Bay, Alaska (see photo on page 129), I wanted more contrast in the sand and a slightly higher value for the whites. You can see by my curve that I selected a couple of spots from dark to dark gray that I lowered a bit. As the curve goes up to white, I raised that a bit. You will learn that by applying a slight S-curve to the shape you will get a nice, gentle increase in contrast. Now you can see the value of a calibrated monitor. If your monitor was set any old way, you would be dealing with unknown values instead of specific values that your printer will faithfully reproduce. Maintaining this baseline is extremely important.

Now, by applying curves to the overall picture, I've helped it by what I call a "global move." Keep in mind though, this has altered your image and if

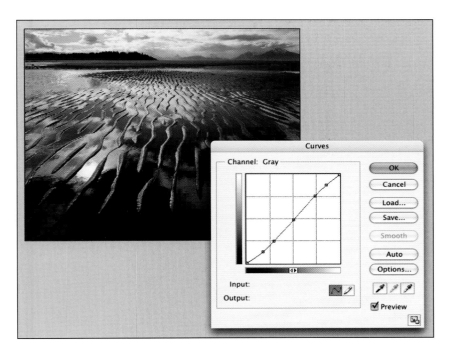

you save over it with the same file name, you will not be able to go back to the original set of tones. Many people just copy the entire image to create a duplicate layer and then apply the curves to the overlying image. This creates a larger file size in Photoshop, but it also protects the original image from changes that go awry. You can also create just an adjustment layer (Layer>New Adjustment Layer>Curves), which sits as a layer on top of the image, and make changes in the curve layer without actually altering the original image. Later you can open that same file and make changes knowing your original is sitting safely underneath it all.

The ability to make layers, which I like to compare to making a club sandwich, is one of the incredible strengths of Photoshop and digital imaging in general. The old days of darkroom dodging and burning of difficult areas of a negative, which for me led to wastebaskets of spoiled prints, are over. Instead, you can now select por-

A slight S-curve to your overall curve layer will usually increase the contrast, giving you deeper blacks and a small increase in the highlights. Doing an alteration on an adjustment layer saves your original image from permanent change.

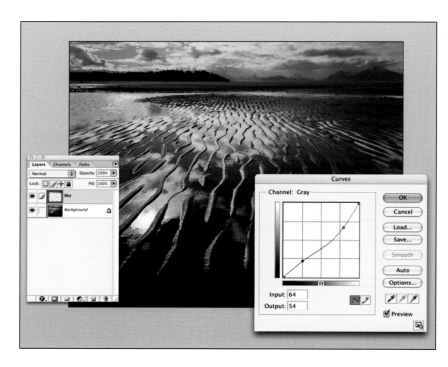

Using a selection tool to extract a new layer containing just the sky allows you to apply a tonal curve to this selection only. Now set opacity to that layer to suit the amount applied to the total image (above) . While working in the sky layer, you can use the dodging tool to delicately lighten the cloud highlights, not unlike what we did in the old dodging days in the darkroom (right).

tions of an image, or the whole image, or certain tones, create masks, you name it, and you can work on these elements with curves or contrast settings to control what you want to control in ways almost impossible to do in the darkroom. The words to pay close attention to in Photoshop are: selection, feathering, layering, adjustment layer, and filters. Books have been written about specialized Photoshop techniques.

Layering can help with difficult areas. I selected the sky with the selection tool and created a new layer. This is simple to do, but requires a gentle

combination of selection and feathering to get just what you want. You need to be careful not to get a cut-and-paste look by slamming through this process. Sometimes it will take many minutes to use a selection tool to trace a natural path through the parts of an image that make logical sense to use. Once you've made a selection (you'll see what we call the crawling ants line) you can copy and then paste a new layer. Clicking on the layer name will allow you to rename it. This keeps things organized if you have a lot of layers.

Next, I highlight the layer I want to work on, which in this case is the sky, and then go to >Image>Adjustments>Curves. I am applying a new curve only to the layer I've created. What is so expressive about this is that you can make some very bold moves and then create an opacity in the layer that gives only a hint or 100 percent of the effect. You can even use the eraser brush to remove parts of the sky layer you don't need, such as a harsh line that you've created with this new layer.

Reading about this can be very tedious, and I suggest that you go in Photoshop and start playing

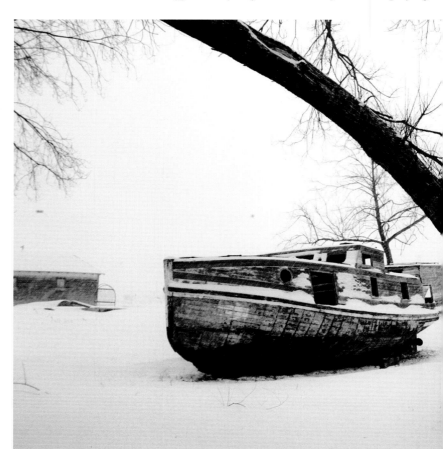

around to see how much or how little of this type of work you need to get into. Serious fine-art photographers and printers use these tools with a high degree of precision, control, and subtlety. There are also serious ethical questions if you apply changes that drastically alter reality. Journalists have lost their jobs because of misuse of Photoshop tools. Fine-art photographers, like painters, have a much wider license to use these powerful imaging tools.

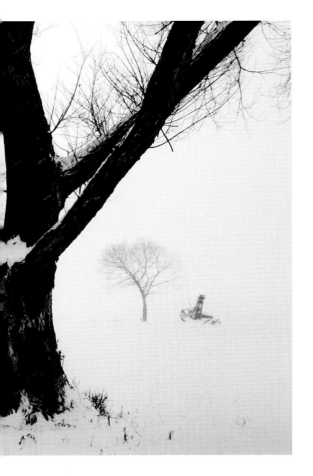

To photograph in either film or digital, then scan and digitally print a high-resolution archival photograph was only a dream just a short while ago. This image was shot with a Hasselblad and film during a Lake Superior snowstorm.

WHEN PHOTOGRAPHERS get together and talk about all the changes in photography, invariably someone will say, "Do you suppose Ansel Adams would embrace this digital stuff?" Not surprisingly, Adams did take a position and expressed it in the introduction to the 1981 edition of his book *The Negative*.

"I eagerly await new concepts and processes," he wrote. "I believe that the electronic image will be the next major advance. Such systems will have their own inherent and inescapable structural characteristics, and the artist and functional practitioner will again strive to comprehend and control them." But in that same introduction, Adams says, "I am grateful for the tremendous contributions of the photographic industry and its scientists, but I cannot help being distressed when 'progress' interferes with creative excellence."

In other words: Embrace change, take advantage of new tools, but always remember that saying something with your camera is the most important aspect of photography.

Though photographers have now been liberated from the basement darkroom and all the noxious chemicals, our path through the "daylight digital darkroom" to that final master print is not without challenges.

At the beginning of the digital printing age, early pioneers made the first beautiful digital prints with $100,000-Iris inkjet proofers. The software cost more than $10,000.

Not long after, I started printing 3 feet by 4 feet exhibit prints for the University of Missouri's

"Pictures of the Year" exhibition. The color prints were stunning, but the black-and-white photographs had a funny green cast. Printer manufacturers were so caught up in the success of their color printers that the limitations of printing straight grayscale images (black-and-white photographs) were mainly overlooked. We were all so swept away by the capabilities of the new inkjet technology that everyone was willing to ignore slight technical issues such as greenish black-and-white prints.

In the early years, the digital pioneers started to develop work using Photoshop to add or subtract

If the monitor is calibrated and your printer has a profile for printing grayscale, your black-and-white images should match your screen. It's important to work for a neutral black-and-white print without any color cast.

colors to achieve a neutral black-and-white print. The desktop printers could only print color images and were totally confused if you sent them a grayscale image. This conversion and color neutralizing was crude, and every time the printer slipped out of alignment, the color tinting really showed. Another aggravation was seeing the color or tint of the print shift depending on whether you looked at it under daylight, tungsten, or fluorescent lighting. This shift of color is called metamerism, a process by which the color of the print changes or shifts with the color temperature of the viewing light.

Third-party ink and software companies soon came up with an all-black-and-white ink conversion for printers such as the Epson 3000. The process required flushing your original color inks and replacing the four CMYK (cyan, magenta, yellow, and black) color positions with all-black inks in various dilutions. This process gave wonderful results, but involved an exhausting process with difficulties such as clogged nozzles and print fading. Until the recent arrival of the 7- and 8-color printers, photographers were stuck with converting their printers to all-black inks.

Now, with the appropriate software or Photoshop techniques, some of the best black-and-white printing is available with off-the-shelf hardware and software available at a price close to what it costs to build a traditional darkroom and fill it with chemicals. Today's high-resolution inkjet printers by Canon, Epson, Hewlett-Packard, Roland, Kodak, and ColorSpan have eclipsed all the dreams and wishes of photographers and graphic artists.

Choosing the Right Printer

Let's look at the available options in setting yourself up for digital black-and-white printing. The first path is a dedicated printer that has had its color inksets replaced with a full set of black inks that

print grayscale-toned images without any of
the worry about metamerism or faint color tints.
The second path is to use a color printer and either
Photoshop or third-party software to print a
neutral-toned black-and-white image with the
existing color set of inks.

I use both, and both give spectacular results. Each
has its challenges or costs, and you could spend from
$500 for a 11x17 paper-size printer up to $3,000 or
more for a wide-format (24-inch-wide) printer. I
suggest starting small and investing in the black-and-
white printing side incrementally as your expertise
grows. If you're a professional, then take the plunge
for one of those gorgeous wide-format printers.

Converting to a Dedicated Black-and-White Printer

Answering the growing demand for a museum-qual-
ity black-and-white digital print, companies such as
Lyson and InkjetMall sprang up. InkjetMall was
started by Jon Cone in the late '90s, and is a pioneer

It's hard to imagine that seven inks flowing through this Epson 9600 can be laid down on a piece of fine-art paper in a complete neutral black-and-white image that will last over a hundred years.

in converting high-end color printers to dedicated black-and-white printers using specially formulated pigment inks and printer profiles. (Printer profiles are embedded commands that take into account your inks and printer and paper and matches them for consistency and accuracy.) Epson printers from the Model 860 on up to the Stylus 9600 now have conversions available using archival pigmented inks profiled with a wide range of fine-art watercolor papers. Their outputs are stunning.

My first results printing black and white on a dedicated printer were on an Epson 3000. With this relatively inexpensive printer and a $300 software package from Cone, I was basically competing with a $90,000 Iris printer using an $18,000 RIP. The process is straightforward. After running the supplied flushing cartridges to remove the incompatible color inks, cartridges of suspended black pigment replace the color positions in your printer. These inks also come in various cold and warm tones to suit your tastes. What was unique to these black-and-white adapted printers was the way their software fired the inkjet nozzles in an overlapping pattern, creating a dot-less look and a smooth grayscale tone. Today, using the printer's own print driver with the company-supplied pure pigment ink and ICC profiles, you can obtain a tonal range from light to dark that some argue exceeds what's possible with traditional darkroom paper.

What Is an ICC Profile?

An ICC profile is a digital file with embedded information that adjusts or corrects color and grayscale information to correct the characteristics or inaccuracies as an image moves in the workflow from scanner to digital camera to monitor and then to a digital printer with specific papers. If your imaging program is ICC savvy like Photo-

> **Tip**
>
> It is a good idea not to let a converted printer sit for months without use, especially during the low humidity of winter. Fire up your printer at least once a week to keep the nozzles clear.

shop, these ICC profiles can be used for proofing on your newly calibrated monitor, which displays the contrast and tonal range of the image as it will print. Your print should be very close to what you see on the monitor if you use the profiles correctly. When I worked in the darkroom, I remember the wastebaskets full of unusable prints. Today, with proofing on a calibrated monitor, I have very few prints that need to be tossed.

Archival Printing

What actually constitutes a print as archival? One friend's opinion is that if a photograph can be handed down to his child and his child can give it to his child, that this might be good enough to call archival. Still, early adopters of color and black-and-white inkjet printing found that color and black inks touted as archival quickly shifted hues or lost density in the blacks, which slowed down the acceptance of this new print technology by collectors and gallery owners.

The good news is that ink and printer manufac-

A profiling Spectrophotometer such as the Eye-One GretagMacbeth can also read a color chart printed by your printer that will then create a "printer profile." This calibrates your computer and printer to print true colors based on these readings.

turers have made big advancements in providing fade-resistant and archival inks, and many of the black-and-white and color ink sets have reached if not surpassed the longevity dates for traditional color and black-and-white prints. For example, recent tests by Wilhelm Imaging Research has placed the life of a black-and-white photo printed on UltraSmooth Fine Art paper with Epson's 7600 or 9600 UltraChrome inks and displayed under UV glass at 300 years. Stored in an archival album box, who knows how long they will last.

Printing Black and White with a Color Printer

Every month brings big changes in the digital world of photography and inkjet printers. In one sense it's exciting and in another way it's frustrating to keep up with all the changes. In the last couple of years, a big step was made for the photographers who need to print black-and-white photographs but do not have the means or space to run a dedicated black-and-white printer along with a color printer.

Enter the Epson line of 7- and 8-ink-position color printers with their archival color Ultra-Chrome inks. The large-format 7600 or even larger 9600, or the smaller Epson 2200 (13x44) and 4000 (17x22) all make wonderful neutral black-and-white prints with the appropriate software RIP or Photoshop tweaking. Hewlett-Packard also has an impressive new series of Designjet printers whose fade-resistant UV inks also make significant advances in color and black-and-white printing for the graphic designer or photographer. There are others, but most of the professionals have settled on either Epson or HP printers. Others you might want to explore are Fuji, Roland, ColorSpan, Canon, and Mutoh printers.

Tip

What is a RIP? A RIP is short for "raster image processor," which is hardware or software that converts images into raster graphic images that can be enlarged and printed without loss of quality.

The Holy Grail

Unfortunately, when printing black-and-white images on many of these printers, there is a perceivable and, in my mind, unacceptable color cast to the images. A printer friend takes her grayscale images and makes a tri-tone image in Photoshop using a formula of three colors to remove the slight tints. Her results are excellent, but on my printer I get a muddy print with a slightly brown tone.

Now enter a software-printing package called ImagePrint by Colorbyte Software. It is an advanced software RIP that works in Windows or Mac OS X and comes with specific paper profiles that allow you to print a completely neutral-toned black-and-white image on fine-art papers.

On one of my first test prints using the Imageprint RIP, I was astonished by the rich neutral blacks, deep shadow detail, and overall smooth tonal transitions in the mid-tones. Some of my

Not all black-and-white prints are equal on a RGB printer. Bottom right was printed as an RGB and has a slight greenish tint. Top right used tri-tone method and was dark and muddy. Top left was printed as gray scale and has a magenta cast. Bottom left was printed though the ImagePrint™ RIP, creating a true neutral black-and-white image.

most difficult prints that really never worked on my dedicated black-and-white printer now had a smooth tonal transition I hadn't been able to achieve. More important was that under all types of lighting conditions, there was absolutely no colorcast. Now I'm consistently printing black-and-white images that surpass all the work I had done in the previous four years. Time is money, and after the initial investment, you will find every penny you spent on this RIP a worthwhile investment in saved frustration and print consistency. Its cost can be justified in the savings alone from not having to run two printers for color and black and white. A RIP has many other features to help in your print-making, such as printing multiple pictures in all sizes—each with color or contrast control—on the same sheet of paper.

Choosing a Paper

Finally, selecting an appropriate archival printing paper is another step in ensuring your images will be around for many years to enjoy. Although it has become increasingly difficult to find quality dark-room printing paper, there is a plethora of beautiful heavyweight 100 percent cotton-sheet inkjet papers available. You should experiment to find what paper weight and surface texture suits your tastes. Explore what Epson, Somerset, Arches, Hahnemühle, and Crane's Museo papers can offer.

I use the Epson Fine Art paper on rolls because I like to print on 16x20 or 24x30 or even larger. Having a flat workspace and developing a system to reverse-roll the sheets as they are cut off the roll will help deal with the curling of paper, mainly a low humidity wintertime problem.

On the Epson (wide-format) printers you have to pick the black ink that matches the type of paper you decide to use. Epson's matte black Ultra-Chrome ink yields a deep black on matte fine-art papers. Its photo black ink yields better results on

luster or glossy papers. For myself, I've settled on a couple of Epson papers; ultrasmooth or smooth fine-art papers from Epson give wonderful results with their matte black ink. Somerset, Hahnemühle, and Arches also have a fine set of inkjet art papers. Once you settle on matte papers or luster papers you will pick the appropriate black ink and prevent the waste of flushing out the black ink as you switch to the other. If you don't match the inks to the paper surface, you will notice bronzing and other unacceptable issues. For those with the need to switch often between matte and luster papers, the Epson 4000 has an eighth black ink, allowing you to switch between matte and glossy paper without changing the inks.

Protecting and Storing Your Prints

One of the biggest differences between fine-art inkjet prints and traditional photographic prints is their fragility. The long-lasting but delicate pigments sprayed on the treated surface of fine-art papers can be easily smudged by dragging another sheet of paper across it. But don't forget that photographic matte prints are also subject to abrasion by rough handling, just not to the degree of the new inkjet prints. Until the prints are behind glass they are vulnerable. You simply have to learn to pick up prints without sliding them, use protective inter-leave sheets such as Light Impressions Apollo Tissue, and carefully store your prints in drawers or archival boxes.

There are also specialized protective sprays designed specifically for inkjet prints. I don't want to deal with the spray, but it's documented that these lacquer-based UV sprays offer protection from light, water, moisture, airborne contaminants, and even fingerprints. Ideally, after printing and spraying, your prints will be stored behind UV glass. Research shows that prints displayed this way can offer over a hundred years of normal light dis-

Tip
To flatten a curled print, tape one end of a large sheet of regular paper to a tube and lay it out on a flat table. Next, place the print face up and lay a protective sheet of fine tissue on the print. Then roll it up in the paper and tube for a few minutes. Unroll, and out comes a perfectly flat print.

Flat-file drawers will organize and protect your prints—an investment that will pay for itself in the long run.

play before any noticeable fading occurs—a longevity that can certainly measure up to black-and-white silver-gelatin print ratings.

What Do We Call These Prints?

Most people who have had long and embroiled arguments about silver-gelatin versus inkjet prints have moved past this issue and have accepted the beauty and elegance of inkjet prints. There is confusion, however, as to what to actually call them. Inkjet just doesn't have that special sound when it rolls off the tongue, yet many think it's affected to use the French term, giclée, which means sprayed with ink.

So what can these beautiful prints be called?

Because various color-pigment and carbon methods of inkjet printing have evolved, several different terms may be needed to cover the techniques. Quite simply, "carbon ink print" for dedicated all-black printers, or "pigment print" for prints derived from a color-pigment printer are technically correct and roll off the tongue nicely. An art gallery can now show a series of black-and-white prints that have either silver gelatin, carbon ink, or pigment ink as their origin and convey the prestige and beauty each medium deserves. Now, wasn't that simple?

Mounting and Displaying Your Print

The most satisfying part about making a photograph is the ability to share it with others. Most photographers are driven to express themselves and the world they view through the sharing and publishing of their photographs. There is no satisfaction greater than to see your image either hanging on the wall or on the printed page being enjoyed by others.

The way you present your images to others is of prime and lasting importance. If you respect your images enough to box them, file them into a nice folder, put protective sheets between prints, or matte them, your presentation will leave a positive impression on those who view your work. I'm not suggesting smoke and mirrors, just that you pay attention to the final way you show your work. Look around and see what other accomplished photographers do with their prints. Talk to gallery owners and ask how they like work presented and see how their shows are hung. A beautiful collection of photographs housed in a simple, clean archival photo box might be adequate for some prints, but your masterpieces deserve to be mounted and hung on the wall, even if it's your own wall.

Tip

Set up a flat work table so you can easily trim or cut paper. If you use roll paper, invest in a couple of wide stainless steel straight-edges. Trimming and holding down your sheets will be manageable, especially if you glue a couple of fine sandpaper pieces to the bottom to keep the paper from slipping when you cut.

NICK KELSH
Capturing Form and Emotion

Nick Kelsh

NICK KELSH is an award-winning photographer and well-known author of nine books, including *How to Be Dad, How to Photograph Your Life,* and *How to Photograph Your Baby.* With author Anna Quindlen, he produced photographs for the bestselling books *Naked Babies* and *Siblings.* He has been a regular contributor to the *Day in the Life* series, and his photos are featured on four of their covers.

Nick attended the University of Missouri's School of Journalism and worked at the *Philadelphia Inquirer* before co-founding Kelsh Wilson Design, a communications firm. Inspired by the stark landscapes of his native Fargo, North Dakota, Nick has long been drawn to the power and simplicity of black-and-white images.

"I know that where you live as a child can imprint you as a photographer for life. I grew up in North Dakota, with the clean, white, high-contrast horizon that went on forever, and that's what attracts me to this day. Now, while I'm living on the East Coast, whenever it snows I go out and make black-and-white pictures. I'm never happier than when I'm walking around in the woods by myself using expensive photo-

"My parents have four boys and a girl. We boys were pretty rough on Jill, and no family portrait was considered successful unless we made her cry. For my book *Siblings*, I wanted an image that showed the tables turned. This picture would have felt totally different if it showed the color of the bathing suits. Instead, it conveys a more serious mood that bright tropical colors would have destroyed."

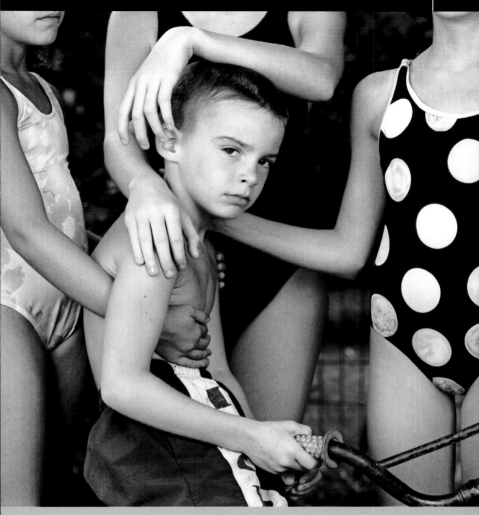

graphic toys and a little skill, and the weather's right. Well, I just love it.

"My interest in photography really started in the eighth grade when we were studying light in our science class. The father of one of the students was a photographer for the *Fargo Forum*. He came in with a portable loading bag, and after he took a picture of the class, he proceeded to process the film inside the loading bag. After a short lecture, he pulled out a strip of developed

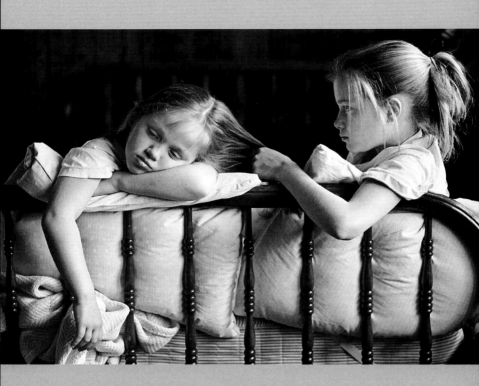

negatives. I was totally amazed and thought to myself, this isn't that complicated, I can do that. From that time forward I was hooked.

"I started to shoot and process film in a cheap bakelite tank, and at a garage sale I found an old enlarger that looked like some sort of vacuum cleaner. For the first six months my prints were really muddy looking. But I kept at it. I got a lot of encouragement from my teachers in Fargo. By the time I was a sophomore in high school, I knew I was going to be a photographer. I wanted to be like the great war photographer, Robert Capa. There was a beautiful black-and-white book by him in the Fargo library, and I think I was the only person who checked it out.

"There were some great early years working at the North Dakota State student paper and then

the *Fargo Forum,* hanging out with the other photographers, learning from all of our mistakes, but having a great time dreaming about getting a brand-new Nikon. These were the years when anything seemed possible. As it turned out, I spent a year (1972) as an intern at the *Belfast Telegraph* and worked under the only photographer there who wanted to actually cover all the serious problems. His name was David Liddle, and he took me under his wing, going on assignments to cover protests and bombings. I was so charged up, until one night men from the IRA broke into David's house during dinner. We all ended up on the floor with guns to our heads. It was a frightening incident. Since the newspaper didn't want any responsibility for my demise, the editor sent me back to the states.

"After the University of Missouri, I worked as a journalist at the *Philadelphia Inquirer* before eventually going out on my own.

"What if students today had a simple chemistry process for color photography they could do at home or in the school lab, while black-and-white photography was the difficult process with expensive darkroom requirements. Would we have all started out as color photographers, thinking of black and white as a luxury? I don't think so. I have always loved the look of black and white. It just touches me in a way that color doesn't. It makes that emotional statement, that simple direct statement that still works for me.

"Black and white distills and simplifies the statement I'm making with my camera. Black and white helps me simplify the image and strip out the unessential, to make a direct, clean image. That's what I'm known for. I don't think that if Robert Capa had shot his war

"This picture always reminds me to keep my eyes and mind open. These girls were waiting for me to set up lights for their portrait and they became bored and started brushing each other's hair. This picture is much better than the preconceived picture I was setting up."

"I love close-ups and details. I also find the skin tones in portraits can be distracting in color, especially in babies. You can avoid the rashes and such; life is much simpler in black and white and important things like moments and expression really come through."

photographs in color they would have affected me the way they did. Color just becomes a distraction when I want to make simple, bold statements. Certainly color can add a lot to the image, but most of the time color can get in the way of the statement. It's like the zebra. Would the zebra be any more stunning and beautiful if its stripes were red and white? I don't think so. It is absolutely beautiful in that strong visual design of black and white.

The early photographers had to learn in black and white, but today with digital cameras, young photographers have easier choices. I'm curious about this new generation of photographers who've grown up with Photoshop. Will they approach black and white the same way? I don't really know, but it will be interesting to find out. When I did the *Naked Babies* book, I wanted bold, clean details, and there was no question about shooting it in black and white. The black and white went so much further in reinforcing Anna Quindlen's words. I don't know if it was the black-and-white photography that did it,

but the book did very well.

"I feel so fortunate that technology has helped me to move from standing over a sink with aching knees to working my photography from a chair in front of a computer. I don't miss the darkroom at all, and I've gained the ability to work my images much closer to how I see them.

"I don't do anything special in Photoshop to convert my color to black and white. Sometimes I use channel mixing, but I don't go to any extraordinary lengths. I've printed black and white my whole career so I know what I like and I seem to be able to pull wonderful prints. With the new big-chip digital cameras and backs, I think I could spend the rest of my life photographing abstracts and landscapes.

"It's not about 'f' stops, computers, or digital this or that, it's about making your photographs express the artistic statement that lies deep in your heart. Creating beauty, which is a uniquely human act, is what is so beautiful about holding that final print in your hands."

Nick Kelsh Tips

■ Knowing when to use a tripod will often raise the quality of your pictures more than any camera bag full of expensive optics. I own ten.

■ Contrary to what you would think, a cloudy day is a great time to shoot nature photographs.

■ A close-up still life will add visual diversity and life to any set of photographs. Details can tell eloquent stories.

■ A good pocket-size digital camera has become a must for any photographer who just wants to be ready.

■ Photoshop has become the darkroom now, and just like the darkroom it will

always be your master. Continue to study.

■ When you've run out of ideas, return to the great photographers for help. Photo books will always recharge your batteries.

■ The best camera for you is the one you will use.

I THINK YOU'VE FIGURED OUT by now that I've only scratched the surface of black-and-white photography. But if you've stuck with me through all the difficult jargon about digital this and digital that, and if you've found an interest in trying to understand the new powerful imaging tools, well, I think you are definitely hooked.

Photography can be a wonderful and enriching art that can enhance your life and bring focus and meaning to an endless array of subject matter. You can dabble in it or you can be totally absorbed. For me, whether I experience it in color or black and white, photography can offer opportunities that never seem to end. It can enrich your physical and spiritual relationship to the world in ways that few undertakings can.

What you need to do is find that perfect and sometimes not-so-perfect balance between all this technical stuff and what you find in your heart as a photographer. It might take a lot of digging and it can come at a price.

I think all this explosive growth in digital imagery is only the beginning of a new flowering in communication. We have all the tools: computers, CD-ROMs, DVDs , the Web, and more. There is no doubt that the visual landscape is changing in our homes and offices as bandwidth, high-definition TV, and devices that seamlessly combine them take shape and change how we view the outside world. When the quality of a television HD image is better

Exploring Madeline Island on Lake Superior during a long cold winter, I found a man who lived by himself without electricity. The only light was from a kerosene lamp, and of course I used a tripod. Unusual light and the right moment can help create a strong image.

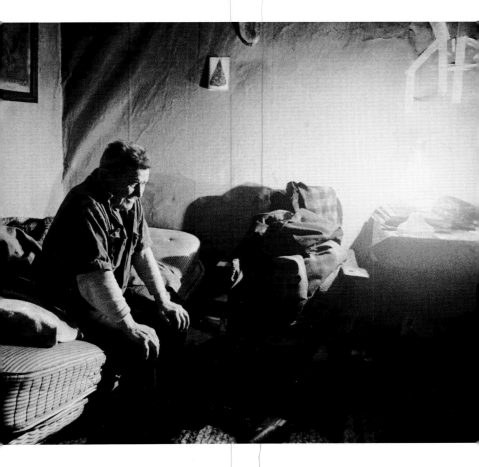

than that of the magazine you hold in your hand, how does this shift the need for still photography?

As a photographer I'm still unclear how this will affect me and my work, but this I know: The beauty of this world coupled with the powerful force of human expression is still waiting to be captured to hold and share with others. In this fleeting life, there is nothing stronger than a visual idea or moment stopped in time forever. And nothing does this better than a black-and-white photograph. This will never change.

FOLLOWING PAGES: You must always stay alert; a wonderful picture can materialize where you least expect it, like this photo of two sisters skirting a field. It was one short moment that I now have forever in black and white.

CHECKLIST

Camera Bag Essentials
- camera bag lined with foam-rubber compartments
- camera body with body cap and neck strap
- favorite lenses with lens caps
- lens hoods
- film and/or media cards for digital cameras
- air blower brush
- lens cleaner solution and lens tissue wipes
- electronic flash
- extra batteries
- remote release
- notebook and permanent marker
- tripod
- leveling bubble for tripod
- computer and extra hard drive for downloading images in field
- DVDs or CD-ROMs for infield backup

Options
- handheld exposure meter
- filters such as UV haze, skylight 1A, polarizing, neutral density, graded neutral density, light amber, light blue
- monopod and/or beanbags
- gaffer's tape
- plastic bag or sheet to protect equipment in wet weather
- soft absorbent towel or chamois
- silica gel for humid weather
- large umbrella
- cooler for hot weather
- extra camera body
- extra electronic flash
- extra handheld exposure meter
- equipment manuals
- selenium cell exposure meter that operates in cold weather
- self-stick labels to identify film
- sunglasses
- head and wrist sweat bands
- camouflage clothing for shooting landscapes with animals
- 18% gray card
- resealable plastic bags for storing film
- customized diopter to match your eye-glass prescription
- reflectors
- slave units for electronic flash
- handheld exposure meter for film
- filters such as UV haze, skylight 1A, yellow or red

Tool Kit
- film changing bag
- film leader retriever
- Swiss Army knife
- filter wrench
- small socket wrenches
- jeweler's screwdrivers
- tweezers
- needle-nosed pliers to loosen jammed tripod joints

Safety
- flashlight
- compass
- whistle
- water
- snacks
- medical first-aid kit
- reflective tape for clothing during nighttime shooting

WEB SITES

This list of websites is a good source of information yet only scratches the surface. This list does not endorse or necessarily approve of the products or information. You can join discussion groups, read articles by and about photographers, and look at the vast online collection of photographers. If you are traveling, you can check the weather and get tips on where to go and what to see. Use a search engine to find sites by photographer's name or by key word.

Adobe Systems Inc. (software), www.adobe.com
AmericanLandScapeGallery.com
Aperture, www.aperture.org
Apple Computer, www.apple.com
ArcSoft (Panorama Maker), www.arcsoft.com Auto FX

(plug-ins and more)
Atlex (paper and inks), Atlex.com
B&H Photo (camera & photo supplies),
www.bhphotovideo.com
Black and White Photography magazine,
www.bandwmag.com
Brian Peterson, www.startribune.com
Camera Arts, www.cameraarts.com
Camera Reviews, www.camerareview.com
CameraWorks (daily news photos),
www.washingtonpost.cameraworks
Canon, www.canon.com
Digital Journalist, www.digitaljournalist.org
Digital Photography Review,
www.dpreview.com
Don Doll, S.J., http://magis.creighton.edu
Epson, www.epson.com
Fujifilm, www.fujifilm.com
Hasselblad medium format camera,
www.hasselblad.com
Imacon Scanner, www.imacon.dk
Imageprint (Image RIP by Colorbyte Soft-
ware), www.colorbytesoftware.com
InkjetMall (dedicated black and white ink
system), www.inkjetmall.com
Kodak, www.kodak.com
LaCie (monitors, calibrators, hard drives),
www.lacie.com
Lexar Media (memory cards), www.lexar
media.com
Luminous Landscape(imaging news),
www.luminouslandscape.com
Lyson Inks (dedicated black and white ink
system), www.lyson.com
Marion Warren, AmericanLandScape-
Gallery.com
Minolta, www.konicaminolta.com
National Association of Photoshop Profes-
sionals, www.photoshopuser.com
National Geographic Society,
www.nationalgeographic.com
Nick Kelsh, www.kidsbykelsh.com
nikMultimedia (plug-ins),
www.nikmultimedia.com
Nikon, www.nikonusa.com
North American Nature Photography Asso-
ciation, www.nanpa.org
Olympus, www.olympus-global.com
Pentax, www.pentax.com
Phase One (large format digital back and

image software), www.phaseone.com
Peterson's Photographic, www.photo-
graphic.com
Really Right Stuff (specialized camera
supports), www.reallyrightstuff.com
Richard Olsenius, Richardolsenius.com
Santa Fe Photographic and Digital Work-
shops, www.sfworkshops.com
Secrets of Digital Photography,
www.digitalsecrets.net
Wacom (graphics tablets),
ww.wacom.com

MAGAZINES

American Photo. Bimonthly publication on
photography.
Camera Arts. Bimonthly includes
portfolios and interviews.
Digital Camera. Bimonthly magazine about
digital cameras and accessories.
The Digital Image. A quarterly publication
Nature Photographer
Outdoor Photographer
PCPhoto
Petersen's PhotoGraphic
Photo District News, monthly professional
news
Popular Photography Magazine
Shutterbug. Monthly publication covering
photographic equipment from film to
digital.
View Camera. Bimonthly magazine cover-
ing large-format photography.

Richard Olsenius is an award-winning
photographer, filmmaker, and former
photo editor at NATIONAL GEOGRAPHIC
magazine. His work spans 30 years and has
appeared in 17 books and over 15 stories
for the National Geographic Society. He
has won over 100 state and national awards
for his photography and filmmaking. Over
the years, he has continued to pursue his
first love—black-and-white, large-format
photography. Olsenius is married and lives
near the Chesapeake Bay. For more infor-
mation on his work, go to www.american-
landscapegallery.com.

Boldface indicates illustrations.